THE ESTHETIC ANIMAL

The Esthetic Animal

Man, the Art-Created Art Creator

Robert Joyce

ILLUSTRATIONS BY THE AUTHOR

An Exposition-University Book

Exposition Press *Hicksville, New York*

First Edition

© 1975 by Robert Joyce
© under the Universal Copyright and Berne Conventions

Library of Congress Catalog Card Number: 75-10619

ISBN 0-682-48300-1

Printed in the United States of America

The keys to. Given!
Finnegans Wake

I wish to thank all those who have
given me help and encouragement,
especially my wife, Peggy.

CONTENTS

THE ESTHETIC ANIMAL

I
HUMAN ESTHETICS

This book is an exposition of a radical and original theory of the arts. It affirms the role of the arts in the evolution of man and in the development of human cultures, from those of Australopithecus to those of modern man.

As the objective world consists of matter formed from atoms and electromagnetic waves, so the subjective world consists of illusions formed from art works. Out of a drummed rhythm here, a picture there, a tune, a gesture, a story, we humans have created our minds and cultures, our systems of values, our moralities and beliefs, our tribes and nations.

All fundamental changes *within* human societies require cultural revolutions. While one of the two primary divisions of human labor, science, has recently given man unprecedented power to control the objective environment, the other, art, is and has been through the ages our only means of shaping and controlling our cultural subjectivity. What we do with the arts, and what we consequently feel to be valuable, can be decisive in determining what we do with our means of production and our means of destruction.

The arts condition us because we experience them as we experience life. We enter into them and—at least temporarily—believe in them. Human beings throughout the past have accepted the arts as experience. The present era is different from those that preceded it because bourgeois man could not allow the arts to be the primary social experience of the people. The capitalist's needs, and his struggles to be free from the domination of the mass arts of feudalism, required him to suppress the arts as vehicles of subjective conditioning, to reduce them to commodities, and to deal with them as objects of trade. Under the esthetics-dominated feudalism of the Middle Ages, the arts must have been experienced every day of the week by every member of society. This esthetic way of life was contradicted—annihilated in some places—by the bourgeois revolution, when art and life were, in Mircea Eliade's word, "desacralized." The quality of human existence changed when art, separated from the people, was made free to do anything—and nothing. It was no longer the fabric of community life, as tribal and feudal art had been, but had become something apart. Art had been "set free," and in the process it

3

had been deprived of its most vital functions—behavior control, culture creation.

The arts are essential to man and to the understanding of man. It is through becoming aware that our cultures and all our cultivated feelings are art products that we see man and his arts as interdependent self-producers—man creating himself as he created his arts. We may find this difficult to accept because the nature of the arts has been obscured, distorted, or falsified over and over again since prehistoric times. The arts have been thus mishandled in good as well as in bad causes, by whatever privileged subgroup controlled the arts in any given society: the misleading advertiser and news-slanting publisher of today, the priest-king and magic-making shaman of the past. Today, a rational image of the past has been projected onto a generally nonrational reality. This scientific view of man and his evolution gives us a skeleton without moving content, an anatomy from which the vital principle is missing.

We cannot deal with man of the past, present, or future unless we take him for what—in addition to being rational—he is: a value-seeking, emotional creature, in large part a product of his arts—the esthetic animal.

Our ancestors could not have become so highly adaptive, they could not have reached human levels, without their reflexes being culturally conditioned through mass arts. Near man and true man could not have generated beliefs, based on fact or fiction, true or false, without having been prepared to do so by the arts. Man could not have developed his innumerable cultures and languages, or handed down the skill of toolmaking from generation to generation without an art-based social organization.

The arts, by which is meant the all-inclusive, ideological mass arts, the arts of the tribal and feudal past and of the advancing cultural revolution, cannot be accounted for in anything less than their full frame of reference in our total cultural existence, just as gravitation cannot be understood as falling apples apart from planetary and solar masses. Although we may accept art works, like apples, one at a time, nevertheless individual works and isolated emotions must be seen as parts of a comprehensive esthetic field. Esthetics includes all our volitional means of evoking emotions and all our experiences of cultivated feeling. In placing the arts at the source of our values, we can see them as generating the centripetal and persuasive force that has drawn together man's organizations. I suggest that the arts played a vital part in the development of human consciousness. I see the arts as fundamental to our existence, as creating the cultures in which we are immersed like fish in the seas. Esthetics is not merely "superstructural," it is what relates us, through the arts, to the incommensurable aspect of the preexisting, material, and objective world.

Dialectics and esthetics, in this view, are interchangeable terms, and the arts are what give us our peculiarly cultural mode of being.

Where man exists as a rational technologist capable of some degree of objectivity, he also exists, in the same person, as subjective and non-rational. The physicist falls in love, the poet measures his lines. Therefore, it is essential to an understanding of the whole man that we see how esthetics relates him to the moving aspects of reality as formal logic relates him to its static, definable forms. Unlike the quantifying sciences, the arts neither assume nor seek limits; they do not measure existence; their reality is nondefinitive. Unfortunately for a rounded understanding of man, his esthetic nature and his esthetic interpretation of part of reality have little place in contemporary theory. We speak of dialectics as process and flux but do not recognize its embodiment in the arts. No theory has told us convincingly how or why the fallen angel or the deviant ape began to produce art, or why he continues to do so. No one has considered the possibility that humanity and its art are truly interdependent; that neither can be accounted for apart from the other. We have, of course, taken it for granted that the human arts could not have appeared without the human beings who produced them. But that the converse might be true— that human beings could not have appeared without their arts—does not seem to have been considered.

The arts should be neither subordinate nor superior to the sciences. The arts and the sciences should be seen as correlated producers of cultures that are at once esthetic and logical. In balance, this would give us a synthesis of the "two cultures." A resolution of opposites, however, requires equal consideration of both elements. The arts await this recognition in a unified view of reality.

The theory of evolution is an important and characteristic product of modern thought. Esthetics has been given no place in it. In his speculations on the emotions, Darwin said that "to understand the origin of human facial expression ought to possess much interest for us." But he turned away from the actor and clown, from art-creating men, to animals and infants for his studies. In the end, he concluded that both the expression and recognition of emotions were "innate and instinctive"— leaving the arts in limbo. But the arts must have been acquired by man at his beginning. They were the only means by which he could communicate, release, and evoke feelings. They were the base of his cultures and shaped his feelings into cultivated emotions. Objective technologies have helped to develop man's rationalism; the arts have given force and direction to his cultivated feelings.

We must embody the arts centrally in our physical and social existence—as coequals of the sciences. We must see them as shaping all

man's reactiveness. This conception relates human emotionalism, including feelings for the right and the beautiful, to the stimulus and response of all organisms, and to the action and reaction of all matter. There is a continuous chain of reactiveness from subatom to galaxy, and from single-cell organism to man. This is an aspect of the general reality that cultivated man, however enamored he may be of his logic, actually apprehends through esthetics. In relation to nature, man must be classified as a highly esthetic as well as a logical creature. The scientist understandably assumes a rational universe; without it there could be no laws. But without an esthetic theory, he must look on his dreaming self as "irrational," and in his supposedly rational, law-abiding, natural world, the irrational is an absurdity. Our understanding of reality—objective as well as subjective—requires the esthetic interpretation to supplement the scientific interpretation.

The arts explain man to himself. They supply the "missing link" in the story of his variation from the other primates. Human cultural existence can be completely explained only in the esthetic reference. Man's evolution, his mind, and his beliefs are inexplicable without the arts. As his survival in the long past owed much to the arts, his passage through the menacing present and into the unknown future requires more than ever an understanding of and a full, wise use of the arts.

II
ANIMAL ESTHETICS

The life sciences are much concerned with such comparative studies as anatomy, physiology, neurology, and ethology. Organic structures and behavior are graded and compared, usually going through the animal kingdom up to man, relating all living things in a scheme of evolution. But there is no discipline devoted to comparative esthetics. Modern time, up to now, has been an Age of Science and, as the arts have been omitted from studies of the animals, they also have been largely left out of the thinking about man.

In writing this book, I consulted many recent works on biology, evolution, genetics, sociology, psychology, and psychopathology. Although all these works address themselves to man, relate their subjects to man, and sometimes are direct studies of man, none deals with man at his most characteristic and peculiar, as the indefatigable art-maker. The same thing holds true, with a few partial exceptions, for works on anthropology, archeology, prehistory, and history. Tables of contents and indexes almost never refer to "esthetics," "arts," "creativity," "fantasy," "imagination," "beauty," "emotion"; there are few or no entries for painting, poetry, music, or other art. I want to state emphatically that man without reference to his arts is indeed Hamlet without the Prince of Denmark.

The logic of science, from Democritus on, says that what is not objective is not evidence of reality. All else, said Galileo echoing Democritus, is "illusion." Art effects are, of course, illusory, and esthetics must defend them as such. In art, what is felt is felt as real, and the evidence of the feelings of men—and of animals other than man—is in their non-rational, inefficient, and even extravagant reactiveness to their arts.

College Zoology by Robert Hegner lists some of the organic bases for the feelings aroused by the arts (though not so ascribed by Hegner). Like something out of Rabelais, the esoteric words for responses to different stimuli make up an intriguing roll: thigmotropism, reaction to contact; chemotropism, reaction to chemicals; thermotropism, reaction to heat; phototropism, reaction to light; electrotropism, reaction to electricity; geotropism, reaction to gravity; chromotropism, reaction to color; rheotropism, reaction to current. Rabelais's Panurge and Friar John would

7

have pleased their great patron, Prince Pantagruel, if they had compiled this thelemic—or scholastic-scientific—catalogue of ways of feeling.

The feelings which the arts of man intensify, and the sense of being which they channel are not objective and are not susceptible to the measurements and objective demonstrations of science. But they are true responses to stimuli—in this case, the arts. All art is illusory and its effects are subjective, but art exists; its effects are real. In any study of man, the arts must be accounted for and "counted in."

To account for man's arts, it is essential to recognize "arts" among the animals. The expressiveness of animals is largely instinctive, genetically programmed. This fact brings into high relief the significant noninstinctiveness of man's arts, out of which the noninstinctiveness of his behavior, his general and unique adaptiveness, has evolved.

The arts which minister to man are also part of the nature that includes all creatures. There is nothing more "natural" than doing something to get an effect. The arts are the principal social means by which man gets his effects, conditioning his reflexes in the process. Among the animals, arts are largely inherited reflexes. They have been "conditioned" into the genes and appear in action as instincts. These inherent arts control animal behavior as created arts induce actions and reactions in generally noninstinctive man. An account of some animal art is necessary as background to a correct projection of human esthetics. The animals could not relate to each other and propagate without their arts any more than man could do so. Furthermore, the sense of existence, the joys and exuberance of life, are made experiential for animals and people by their arts, different as their arts may be from each other.

I stopped work one day to watch a pair of sparrows courting on a near-by flat roof. The male not only gave his characteristic chirps and rattles, he also sounded prettier notes, musical phrases that apparently come to him only at mating time. It was spring, and instinct was putting on one of its millions of annual art shows. The cock sparrow was urgent, insistent, pleading. The female presently responded with low-keyed trills as the male hopped and flew back and forth, a frantic gray-brown dust-ball, going around and around his love-object, grating and fluting his romantic song, dancing his ballet. I watched until, with louder chirps and short flights, he lured her away from my window.

The recognition of these natural arts allows us to connect our more variable arts with the instinctive or genetically programmed arts of other organisms. The latter arts, although generally unchanging where the environment does not change beyond seasonal variations, are nevertheless means of adaptation to such relatively stable environments. Our own altogether learned and continually recreated arts are our quicker and more flexible means of adaptation to the varying environments that we

seek and create. Our free use of arts might be called instant adaptation.

The rainbow of esthetics arches from man over the whole animal kingdom and beyond. We can appreciate a thrush's song and a butterfly's colors as if they were human art creations. We can also appreciate them as esthetic works on their own levels, as arts parallel to our own arts and prior to them. Such arts cannot be ruled out of esthetics simply because they are conveyors of genetically conditioned reflexes rather than changeable governors of behavior displacing the instincts, as man's arts are.

In the context of an inclusive esthetics, the arts relate man to all life and to all matter. Esthetics is traceable through the animal kingdom and the vegetable kingdom down to inorganic matter. Everything adapts its position and shape to pressure. Stars wheel in the grip of galaxies. Plants bend in the wind and grow toward the light. All organisms respond to the pressures and attractions of stimuli, and many have special ways of projecting evocative messages. The use of the techniques of art by other creatures prefigures man's use of arts, just as the responses to stimuli by animals anticipate our emotions, and the forms taken by those responses match and anticipate our own, as Darwin noticed. Bisexual propagation is usually, if not always, keyed to an emotive signal system. Instinct-directed animal arts bring the responses that are the species' long-range accommodations to an environment. These inherently transmitted adaptive responses, these instincts, have been selectively fostered in the genes, which carry them through the generations. The wooing behavior of a pigeon or cat, the annual nuptial flights of the ant, bee, and termite have endured from the species' beginning. They are instinctive "trains of unlearned behavior," yet they are fixed in patterns that are sometimes strikingly nonrational. They seem to use the most rather than the least means; they are extravagant, roundabout, inefficient—and effective. In a word, they are artistic.

The arts that relate us to the other creatures also distinguish us from them. In a world full of stimuli, the instincts seem to tell the animals what to respond to, what to feel. Man must invent what is to move him, and what is to be his response. The human infant's formless feelings await the cultural mold of the arts that implement his free adaptiveness. Instinctive animal arts carry less variable sequences of adjustments. Gene-programmed biochemistry forces the animal to conform. Nonhuman species have biologically safer connections between objective circumstances, such as change of seasons; and subjective readiness, such as seasonal "heats." When the time comes around, the ant and the zebra must breed. Man, however, whether he is aware of it or not, must be moved culturally in all his feelings, including the sexual.

Every creature other than man has means of communication that are largely fixed at birth and therefore comparatively limited. Signaling de-

vices mentioned by ethologist Niko Tinbergen are preening, advance (or "threat") and retreat, flushing, and hair and feather-raising. Zoologist Edward Q. Wilson tells us that when a honeybee wants to tell her hive-mates where she has just found food, she does a "wiggle dance . . . a miniaturized version . . . a reenactment" of her trip "complete with wing buzzing to represent the actual motor activity required" (*Scientific American*, September 1972). A limited means of communication provides limited exploitation of the possibilities of emotive signaling. Man's arts, being altogether adaptive and therefore unlimited, can expand indefinitely. So can his imagination and his views of reality.

Art is the employment of effects to produce affects. Since most life is nonhuman, most affective expressions, up to now, have been nonhuman: In other words, most art has been animal art. Urbanized man has been made to forget something of which tribal man was always aware: Affective behavior, art, permeates nature. Under industrialization, man feels little connection between his cultures and anything existing in nature. The instant response we make to our music and our visual and verbal arts should remind us that esthetics has its origin in the instinctive reaction to stimuli common to all life. A few quotations and paraphrases from some naturalists will allow the reader to judge to what extent animal arts are arts.

The other two-legged singer, dancer, and ceremonial builder, the bird, is one of man's most interesting art rivals. When courting, the male of the rose-colored starling does a dance around the female. He goes with short, quick steps and vibrating quills, singing all the while. "The lady at first is passive," zoologist N. J. Berrill writes, "but soon is drawn to join him, and round they go, faster and faster; then suddenly they mate. The dance of the goonies—an albatross—is more majestic. Male and female stand face to face with wings partly spread, surrounded by a large circle of shouting and clacking onlookers. The two performers raise their heads toward the sky, then duck to the ground only to rise again touching beak to beak. The beaks are ducked first under the left wing and then the right, and heads are reared once more to the sky—dancers matching step for step. As the rhythm increases, the clacking of the outer circle reaches a crescendo—and if the dancing male should tire or falter, another waiting on the sidelines slips in and takes up the dance. The ceremony broadens and it is no longer a private party. . . . Razor-bills . . . have a paddling dance on the surface of the sea. At first they move in single file, then converge toward each other until their raised beaks almost touch in the center of the group—it is even more uncanny since the moving feet are invisible beneath the water. The circle swells, then breaks—each pair of birds bob, come together and hold beaks, and for a few seconds waltz around each other. Then a single file once more,

with beaks and tails lifted as high as possible, and then again the ring, the ecstatic facing of the pairs, the waltzing, and back to the file in the state of rapture."

In the mating season, each male prairie chicken struts; and by means of inflated air sacs, he makes booming sounds, displays his feathers, and puffs up in front of the female.

The art plumage of the snipelike ruff is not standardized. One male may have a purple ruff; others may have white, brown, or variegated collars. Migrating in spring from Africa to Europe, these birds gather in a customary mating arena, each with his own small court staked out. On the appearance of a female, they rush around with ruffs erect. They then fall into what E. Thomas Gilliard, a curator of birds at the American Museum of Natural History, describes as veritable trances in which they shiver at the female's feet with beaks touching the ground, awaiting her choice.

Members of one species of manakins, which mate in the jungles of Panama, provide themselves with small ground clearings which they keep free of litter. When a female appears, each male tries to lead her to his small clearing, flitting from branch to branch and calling. He enters his clearing, says Berrill, "with a loud snap made by his wings that can be heard for three hundred yards—and with a snap-snap springs from one side of the court to the other. It is all done by the dancing, snapping invitation . . . and if she chooses to accept, she joins in and the two birds leap rhythmically across the court, passing in midair. When the duet comes to an end, the couple disappears into the more secluded privacy of the forest. . . .

"The crested screamers of the Argentine ascend in a musical, soaring flight in pairs—they are said to mate for life and their duet accentuates the harmony of their respective rhythms. The male begins, the female takes up her part, and together they pour out a torrent of sounds, some deep like drumbeats, others clear and ringing. . . . In the Central American rain forest, as night descends . . . wood quail stand face to face, male and female, and sing in harmony and rhythm so perfect that it seems to be a single song."

Gilliard says that the buff-breasted wren of Panama has a song composed of four parts, two led by the male in a duet, then another two led by the female. The organ bird of Amazonia (a wren) "produces notes that seem to stem from a highly trained human voice or from a flute." Dr. F. M. Chapman, "out of sheer admiration," named another of these wrens "the composer."* In the rain forests of the southern Pacific, says

*Quoted in E. T. Gilliard, *Living Birds of the World* (Garden City: Doubleday & Co., Inc., 1958).

Berrill, the great birds of paradise gather in small bands upon a particular tree, and they go through a dance that displays their plumes, "accompanied by much loud calling." The male, in the chosen instance, was a chestnut brown "with magnificent yellow plumes springing from each side and trailing beyond the tail. . . . To the accompaniment of a low croaking call, the dance commences—wings open, plumes are raised, the state of ecstacy becomes intense; then wings droop and plumes rise over the back, falling in a cascade. The whole bird is overshadowed by them, with crouching yellow head and emerald green throat forming the pedestal for the golden glory waving above the deep red base. A loud call, a shaking of the plumes, and the display is over."

Each of the male lyre birds of Australia builds himself several mounds upon which he displays his plumage to the females, and ". . . from each mound in turn," says Berrill, "he sings his songs—possibly the largest and most lovely repertoire on this earth. . . . Throughout May and June all the male's power of mimicking other birds' songs is called into play, but from then until mid-July the song changes into the long, warbling, mellow, nuptial song of his own kind—singing it over and over from dawn until dark. During this period the birds are never apart, going from mound to mound, at each of which the male stops to sing and display his manly charms."

"The peacock exhibits his gorgeous train, shows it off by strutting, rattles the quills of his feathers, and screams," writes Professor H. M. Fox. "Cock pheasants, peacocks, and turkey cocks . . . indulge in the most elaborate displays. . . . The barnyard cock circles round the hen in a slanting run with one wing drooped and head down, showing his bright colors. The argus pheasant opens his wings like a huge flower, throws them forward, and makes a screen before his head."

The architectural works of the bower birds are found in Australia, New Guinea, and the neighboring islands, according to Gilliard (*Scientific American*, August 1963). The satin bower bird constructs a bower with two parallel walls of arched twigs. In front is a display ground decorated with a variety of blue objects. The builder, as described by Australian zoologist A. J. Marshall, having lured the female to his bower, parades before her with a blue flower in his beak (*Scientific American*, June 1956). In otherwise somber forests, the decorated display grounds of this and other species of the bower birds stand out with their brilliant splashes of color. They may contain feathers, flowers, fragments of glass, crockery, rags, paper, and shells. A thrush-size "maypole-building" bower bird makes pyramidal structures as much as nine feet high for his show. Some of these have formal forecourts, strewn with freshly picked flowers, fruits, and colorful fungi. One bird surrounds his bower with a low parapet of transplanted moss. The blue-black satin bower bird mixes paint in his

mouth, devises a tool of bark to aid him, and then plasters the inner walls of his bower with pigment.

Animal esthetics is constant but is not always so spectacular. The three-spined stickleback, a small fish, assumes a bright red belly at mating time. Upside down, he shows off his flaming abdomen to lure females to his nesting area and to warn off rival males. In the spring, the courting male uca crab of the Pacific coast of America shows his fresh colors to the female and, as described by Professor Fox, literally dances her along in the circle of an outsized claw, adding a clog step to a prancing jig, revolving slowly before her so that he shows to the best advantage. Scorpions also dance in pairs, sidewise or backwards, claws locked. Some male spiders use visual signs, semaphoring to the female; others woo by touch, and still others signal their presence and stimulate interest through tweaks and vibrations on the thread of the web.

If a female grayling butterfly alights near a male, he will run around her, opening and closing his wings and fanning his scent toward her. Man does not use scent a great deal to stimulate his emotions, but François Bourlière has observed that "olfactory signals must play an important part in the daily life of the wild mammals." Urine and fecal matter, musk and other odorous secretions stimulate their sense of smell. "But unfortunately, it is very difficult for us to appreciate the role of odors because of our own mediocre sense of smell." The nose of any dog in the streets points to a world of olfactory esthetics. Scent is not the only sensory field in which the other creatures differ from and sometimes surpass man. There are longer and shorter radiations than the narrow waveband on which the human eye receives light, just as there are sounds above and below our range of hearing. We cannot perceive the bat's squeak because it is ultrasonic, above the 16,000 vibrations per second that we can hear, while sound vibrations below 16 per second are also inaudible to us.

Our mammalian relatives generally are poor in the sight and sound displays with which man rivals the birds. Among those other mammals "we scarcely find any equivalent of those courtship activities in which birds display the most brilliantly colored portions of their plumage," says Bourlière. As the mammals are inferior to the birds in song, dance, and display, so the other primates are noticeably weaker in arts than man. It is their esthetic poverty that makes the apes most strikingly unlike us. Yet it is true that gorillas beating dramatically on their chests as a warning were observed in the wild by scientist George Schaller. Vernon and Frances Reynolds report: "One of [the chimpanzees'] best-known characteristics is the loud drumming they do on tree buttresses, which carries as far as two miles in the forest." These animals sometimes adorn themselves with leaves and, "both in freedom and captivity, the most

competent observers, like Carpenter, Kohler, and Zuckerman, whose authority is beyond dispute, have often seen chimpanzees perform a childish round while holding hands," says André Senet. It is also reported that monkeys and apes have a variety of more or less significant facial expressions. Nevertheless, the outstanding thing about ape art is its poorness.

Semi-upright, with an almost man-sized brain, with bifocal vision and dextrous hands, but with a meagerness of emotive communication, the ape should long since have served as a demonstration that art-creation and art-response are the primordial differences between ape and man, as well as being the earliest means through which man raised his biological status. Assuming an esthetic continuum, it is the ape who has turned aside from the evocative behavior that is displayed by man and other talented creatures. Since Darwin, we have grown accustomed to the idea of structural, rather than behavioral, relationships among living things. We have accepted our cousinship with the apes too uncritically.

The artless primates are morphologically close to man, but they are emotionally remote from us. Being so artless, the apes are incapable of refinements of communicable feelings and of thought. They are what man would be without arts—insensate brutes. Feeling is the subjective experience of being, and the persuasion to feel is the essence of art. We empathize with the captive owl that, according to Professor Fox, lovingly fed its keeper when it was deprived of an owl mate. We feel with Konrad Lorenz's lonely budgerigar that loved a Ping-Pong ball. Whatever makes for inward motions, whatever celebrates and enriches being, is art, and testifies to esthetics.

The modern disjunctions of science and art have increased the alienation of man from nature to the degree that more and more man simply exploits and wastes the natural world. Only the arts and the cultural revolution can reconcile the part of life that is man with the rest of life.

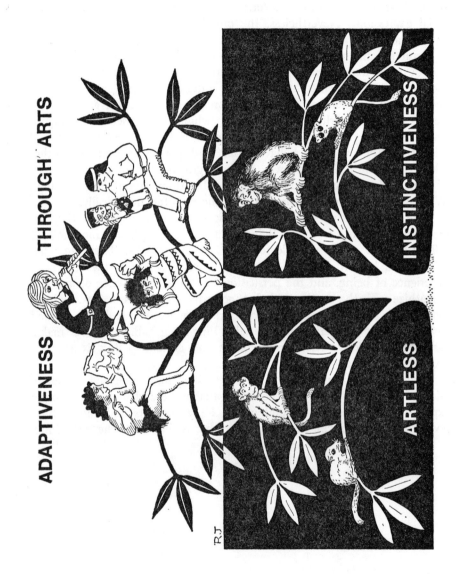

III
ART AND EVOLUTION

"What is needed . . . is a theory of cultural evolution as comprehensive as the theory of biological evolution."
Anatol Rapoport, *Scientific American*, October 1965

Biological evolution is thought to work by natural selection through physical variations arising out of crossed strains within a species or genus, and through gene mutations directly altering an inherited form. When an inheritable variation produces advantages to the species as a whole, the species is changed for the better. Variations in fossil forms and in the forms of living creatures are thought to show how differences within species led to changes in the forms of species and to new species. Changes in body size or in the strength of the jaws or the size and sharpness of teeth are variations found in prehistoric and contemporary animals. Man varied in an odd way. He became physically weaker and acquired an enlarged brain that, objectively, he put to little use. And, he varied in his behavior by losing "instinctiveness." This loss brought about another striking and art-related change in our species. This was the change in sexual behavior which must have taken place in man's evolution. "Most mammals show estrus cycles characterized by heat behavior," observes sociologist William Etkin. "Primates, other than man, show estrus and menstrual cycles; man shows only menstrual cycles." Woman was very early free of the instinct-domination by which the tabby, the vixen, the cow, and the mare are mercilessly compelled to breed in their seasons. Woman, because she could accept art, was stimulated by the persuasion and the reflex conditioning of the arts. Thus, even with the loss of instinctiveness, mankind continued to breed and not only survived but also multiplied.

Our ancestors were not made objectively and demonstrably more rational by the enlargement of the brain or by an extension of the areas of conditionable behavior. Early man was little—if at all—better prepared for getting his food than the tiger and the goat. Archeologist V. Gordon Childe said, "Man is now, and was apparently from his first ap-

17

pearance in the Pleistocene, inadequately adapted for survival in any particular environment. His bodily equipment for coping with any special set of conditions is inferior to that of most animals." Anthropologist Loren Eiseley asked, "How did the human brain develop so far beyond what was needed to secure the bodily safety and primitive needs of its possessor?"

With these apparent disadvantages, how did our species, or its progenitors, survive? From emphasis on the enlarged brain and stone tools, we of the scientific age are expected to infer, and sometimes are told, that survival owed to rational intelligence. The evidence and the probabilities are against this. Eiseley, in 1956, said that the time ought to be past when the employment of stone tools can be used as an explanation for the development of the human mind. "The idea . . . of a creature evolved solely by the dextrous use of a flint axe is appalling. . . . It [still] recurs in anthropological discussions." Stuart Piggott, professor of archeology at the University of Edinburgh, called the slowness of human technological progress the most striking thing about man's industries from more than 500,000 to 10,000 years ago. To the rationalistic anomalies of the enlarged brain and of survival in spite of weakness and reduced instinctiveness, is added that of early man's creeping technology. This slower-than-glacial advance—as slow as three or four known glaciations in man's time—only reached from chipped stone to polished stone a few thousand years ago. Where, during man's previous time, was the "rational," the "toolmaking" animal, *Homo sapiens?* And where were the human types more recently labeled by scientific classifiers? *Homo faber* was the consistent maker of what besides art? *Homo habilis*, the skillful one, used his skill to produce fantastic varieties of myths and other art products while he was satisfied merely to "get by" as technologist and scientist.

Alfred Russel Wallace, the co-discoverer with Darwin of the theory of evolution, was puzzled by preliterate man's large brain. Wallace maintained that natural selection would have given the savage a brain only a little better than that of an ape, whereas he actually has one that is about as good as that of the average member of learned societies. The brain of the living "primitive," the "savage," contains potential abilities for which he has no use in a preliterate state. Eiseley asks, "How is it that Wallace's dictum has held true that man in . . . remote districts has latent capacities very similar to, if not equal to those possessed in the civilized centers of the world? This Negro, in other words, who has paddled a dugout canoe along dark and tree-hung waterways, this Indian who has gestured naked on a lonely pinnacle at ships bound through the freezing waters of the Horn, possessed somewhere beneath the tangle of his unkempt hair the same pulsing electronic patterns that on other

lands have measured the stars, or weighed evidence in the seats of judgment, or twinkled like fireflies as the lines of a great poem woke its strange sad memories in the brain of man. . . ."

Wallace's puzzlement at the size of man's brain raises the question whether size alone could, in any significant way, determine intelligence. The social insects and the birds get along with small brains, and the intellectually unimpressive dolphins and whales have convoluted mammalian brains that are as large as or larger than man's. In a fantastic cautionary tale, physicist Leo Szilard was half in earnest when he wrote: "The organization of the brain of the dolphin has a complexity comparable to that of man. . . . The intelligence of the dolphins might be equal to that of humans, or possibly even superior to it." In a less fanciful vein, Stuart Piggott has quoted Julian Huxley: "[Man's] brain had so developed that it endowed him with a second method of heredity based on the transmission of experience, and launched him into a new phase of evolution based on ideas and knowledge." Huxley's explanation of the brain does not answer Wallace clearly, however. If we suppose "ideas" to mean rational ideas and "knowledge" to refer to objective scientific knowledge, we speak of things that simply were not available to man in the beginning and were still rare a few thousand years ago. What then was the human brain occupied with before it got these objective ideas and this modern knowledge? Without placing the arts as *the* evolutionary force already operating at a very early stage of man's development, such speculation leaves science where it started—without factual or convincing hypothetical answers—in attempting to account for the culture-creator.

Early in the Pleistocene, which is to say about the time that the last series of ice ages began, a million or more years ago, the brain of the creature who was becoming man expanded explosively, according to Loren Eiseley. "Our infancy," he said, "became the most helpless of any of the animals because everything had to wait upon the development of that fast-growing mushroom which had sprung up in our heads." Since man is born at a stage equivalent to a seven-month ape embryo, we became, in effect, living miscarriages whose large heads and inadequately developed bodies have been described by Eiseley and other eminent specialists as "fetal" or "pedomorphic." But our fetalism meant that we could continue to grow mentally. A director of the British Museum of Natural History, Gavin de Beer, said, "It appears that if infancy is lengthened, there is a correspondingly lengthier retention of embryonic tissue capable of undergoing change." So, as man in certain characteristics remained infantile, he was better able to learn than early-maturing creatures.

What was the large-brained man of the early Pleistocene learning that the wild pig was not also learning? This animal, like most others,

was a primitive botanist and zoologist. It learned and taught its young, which did not remain fetally helpless, what was good to eat, where to find it, how to survive. Man, too, had to learn these things, and because the human infant had its pedomorphic character, especially in the expanding brain tissues, he could learn much more. What he learned beyond a simple knowledge of foraging and the tool-use that remained rudimentary for most of the millions of his protohuman years was to create arts.

The proposition that man, having become man, had previously become an artist is not difficult to accept. The ability to create and sustain illusions is manifested early in the play of children and is probably shared to a limited extent by animals, especially young mammals, which also play. The more serious impressiveness of the arts, the ceremonial uses of color and form, of sound and movement, have their precedents, as previously mentioned, in the instinctive, ritualized arts of the birds. The projection and acceptance of make-believe, then, may not be a complicated matter. On the other hand, the sustaining of illusions and the exploitation of their possibilities were not simple matters. The first required the new, enlarged brain, and the second is the story of culture and the continuing struggle of man to make himself.

The light of culture continues to dazzle its creator. "The profound shock of the leap from animal to human status is echoing still in the depths of our subconscious minds," says Dr. Eiseley. "It is a transition which would seem to have demanded considerable rapidity of adjustment in order for human beings to have survived, and it also involved the growth of prolonged bonds of affection in the subfamily, because otherwise its naked helpless offspring would have perished. It is not beyond the range of possibility that this strange reduction of instincts in man in some manner forced a precipitous brain growth as a compensation—something that had to be hurried for survival purposes. Man's competition, it would thus appear, may have been much less with his own kind than with the dire necessity of building about him a world of ideas to replace his lost animal environment. . . . Science, which can show us the broken skulls of our dead fathers, has yet to explain how we came so far so fast."

The illumination of his arts showed protoman how to see and to feel volitionally. The illusion of things, and the sounds, hues, curved and angular forms, and motions of the arts made a world to see for the first time, because only when man was seeing creative and illusionary possibilities in the world was he able to see it imaginatively, culturally.

This was the greatest revolution man was ever to know, one whose promises he has still to fulfill. On one side was the ancient way of life, the contentment of the living, painless moment, a way shared equally with the ox and with the tree-hanging monkey and the shambling ape.

On the other side was the dawning mind enabled by art to look into the stars and into itself, seeing for the first time the universe and the big-headed, clownish pedomorph putting on its tragic dignity. This change must have come about rapidly, all more or less at once. It happened when voices rose deliberately in the conscious performance of a rhythmic beat, and when the line of dancers formed up deliberately. Although it may have taken millennia to develop further, yet at that moment the illusions of art instantly became the reality of culture.

We reenact the birth of culture every time we are moved by art. To experience this consciously, each of us should look again at whatever visual art has the power to transport us, and listen again to esthetic sounds or words that elate us or make our hair stand on end. Then we are in a rocky recess in Olduvai Gorge, millions of years ago, and as we look and listen with our shaggy stooped fellows, we are at the birth of freely adaptive art and of mankind.

 If we do not credit the arts with a decisive role in man's evolution, the physical drift of that evolution makes no sense. The result of that drift—and it was successful—was a food-gatherer and hunter, big-headed, clawless, comparatively weak and slow, with a reduced sense of smell and badly engineered internal organs hung in an awkward upright frame. This creature would seem to have had little chance of survival—but he did survive. It is consistent with what we see today in cultures around the world, and with the few remains of ancient man so far discovered, to say that this primitive food-gatherer was as preoccupied with the arts as are contemporary tribal wanderers or settled village and city dwellers, and that his large brain was put to use, as at least a part of it still is in all contemporary communities, in creating and receiving arts. The variation toward physical weakness would have made it necessary for him to operate in groups. The arts must have provided him with an adaptive, noninstinctive way of organizing such groups. His principal task throughout the Paleolithic epoch was developing his cultures and his esthetically magnetized societies. Early man danced and clapped, chanted and acted himself into effective groups, into new levels of cooperative work and consciousness. Through this art organization, he was able to survive and, slowly but steadily, to multiply until his kind had spread from its place of origin in Africa or Asia to every other part of the world.

In relation to the culture-maker, the outsized brain is not biologically unaccountable. If we were not so receptive imaginatively and so adaptive emotionally, a central nervous system doubling and redoubling in size (ape brains, 250 to 500 cubic centimeters; *Australopithecus*, 500 to 850; *Homo erectus* [Pithecanthropus], 700 to 1000; *sapiens*, about 1400) would be a handicap rather than an asset. (The brain of the Neanderthal variety of *erectus* was as large as 1550 cubic centimeters. He was, signifi-

Idol arrow'd 'round.

cantly, a ritualizer who experimented with art effects.) Our survival
and multiplication owe to the early esthetic utilization of the enlarging
brain. Without the arts there would have been no imagination, no affec-
tive communication, and no extension of reflex conditioning. Without
such emotionally directive communication there would have been no
organization and no social and cultural man.

To vary in the direction of *sapiens*, ancestral proto-*sapiens* or pre-
sapiens must have evolved in the earliest times toward the artistic creator-
performer. He might easily have acquired an evocative repertory through
imitation, in the "Monkey see, monkey do" way. The apes are not
imitators, in the opinions of Kohler and Zuckerman (other experts such
as Yerkes disagree), but this proves nothing either way, since the pri-
mates in question did not evolve into art-producers. An artistic bent,
perhaps starting with imitations, might have been the variation that
distinguished ancestral man from the progenitor of the apes. There are
precedents in nature for some animals "aping" the appearances, sounds,
or motions of others. The male mockingbird, for example, will run
through twenty or more songs of other birds, and imitate a number of
man-made noises as well. The primate-on-the-way-to-man could have pro-
vided this kind of art projection by imitating calls and gaits, by simu-
lating flight and pursuit, and by creating other illusions.

Art was the work with which emerging man mostly occupied himself.
Almost upright, two-handed, varying toward adaptability, protoman could
make a better percussion instrument with a hollow log and a stick than
the chimpanzees could do using tree buttresses as drums. Protoman
could daub his skin with colors, dress in molted plumes, fur, or bark, in
cast antlers and horns. Animated shadows thrown on rock-shelter walls
at sunset would prefigure mural paintings, the movies, and television by
hundreds of thousands of years. A shadow outlined with charcoal on
shale or with a twig in sand becomes a drawing, given a creature that
could see and make it. Red or yellow earth, or chalk or organic fluid,
mixed with grease becomes oil paint—or watercolors if mixed with
water. These could be applied to human skin, to cave as to cathedral
walls. Picture-making was to become a part of man's life throughout the
ages. Behind were left the troops and families of apes, before lay adaptive
cultural organization and man's freedom to begin making himself. At
hand in the arts was the tool with which to make this transformation.

Creativeness and responsiveness to the arts probably were the evo-
lutionary factors that sorted out variations for survival from among
diversifying types of protomen and early men. If each variation in suc-
cession was more adaptably sensitive to the arts than its predecessors,
and therefore less instinctive, the motivational and organizational powers
of the arts would have been at hand to carry out the task of natural

selection. Homo sapiens was on the scene 60,000 years ago, and the bones of *Homo erectus* have been dated at nearly 3,000,000 years ago. Mingled burials of the bones of ancient and modern types of man, dating from about 100,000 years ago, were found in a cave at Mount Carmel, in Palestine. These time spans apparently were long enough for the evolutionary process to work out. Perhaps physically and culturally old-fashioned "Neanderthal" or *Homo* erectus artists competed in Eurasia and Africa with esthetically more resourceful "Cro-Magnon" types of *sapiens* in music-making, miming, and other arts. Apart from such speculations, we know that *sapiens* survived and we know he makes and absorbs arts endlessly. These facts surely deserve a central place in our theories about man's peculiar physique, his peculiar behavior, and his astonishing survival.

We have accounted here through emotional rather than rational hypotheses for the appearance in an evolutionary sequence of man's enlarging brain with its latent rational capacities. We need not assume primitive tendencies toward a logic and sciences that were not there. The pipe made from a hollow reed, the twig charred for drawing, the stone chipped for engraving, crude brushes with which to paint the body, would have been advances in toolmaking for nonrational purposes. The first known lamp lighted the caves for ancient muralists and was an adjunct to art. Like many savage skills—perhaps it would be fair to say like most savage skills—these would be technological advances produced in the arts, technologies serving emotional rather than rational needs. The resulting techniques ultimately contributed to objective rationality, but this was incidental, as we can conclude, because such rationality was so late in development. Early man's few advances in toolmaking may all have been initiated as adjuncts to the arts and carried no further, since, as such, they were satisfactory.

In later prehistory, the arts unwittingly checked, or at least failed to stimulate, scientific progress. In recent historical times, the sciences have unwittingly returned the disservice, as for example in evolutionary theory where it assumes that all the world, like science itself, progresses. Under the influence of Darwinism, it was naturally, but mistakenly, thought that esthetics progresses, that the arts evolve. However, the arts, in their nature, are not progressive or evolutionary. Hence our ability to enjoy ancient arts. The arts are dialectical, existential and ontological—dialectical in their relation to the sciences, existential and ontological because whatever moves an audience at a given moment has a self-evident being; it exists adequately for the moment. Science changes continually; art changes only in form and then only when, in the old form, it fails to move its audience. Art is the "unmoved mover" which, while playing an essential part in evolution, does not necessarily go forward as the sciences

do. The existential arts and the progressing sciences must resolve their contradictions in the synthesis of our cultural values. Science is not concerned with values but, as in its very nature it advances, it gathers more facts and so gets valuably "better," or "truer." Art is the medium through which we produce our cultural values, our judgments of better or worse, our good or bad. Yet art is not in its nature either good or bad; it is simply moving or unmoving.

From the confusion about progress has come much that is most characteristic in late nineteenth- and twentieth-century Western arts. They compulsively seek new forms because the overwhelming influence of scientific rationalism has put the arts into the framework of evolution where they are seemingly *required* to change. And ironically, while art works apparently progress in form, their moving (esthetic) content is left out. We hear of evolutionary and revolutionary gains in the arts, comparable to those of technology and the sciences. But in the sense of esthetic progress, of the esthetically more or truer or better, we know, if we look back over the ages of art, that such gains simply are not there. The incommensurable added to the incommensurable comes to another incommensurable. The arts, of course, have changed in the past. They changed their forms when the reciter became a writer, when picture-making went from fresco to oils to photograph to electronic tube. The sizes, shapes, and numbers of art works have changed as technology has changed.

But as means of effecting emotional responses, as pseudoexperiences, the arts of the Paleolithic, the Neolithic, and the twentieth century are essentially the same. Some of us admire Indian blankets, peasant pottery, African masks, the cave paintings at Lascaux—the Beatles as well as Beethoven. What one of the "three Bs" was to a Victorian music-lover, Charlie Parker is to a jazz-lover, and Scott Joplin is to a fan of ragtime. The ventriloquism of a shaman in a Siberian hut is art to his fascinated audience; the drumming and chanting of men in a secret jungle lodge during an initiation is art to the participants. The rhythmic stamp, clap, and shout of protoman would have been art to his audience, just as the drilling tattoo of the amorous woodpecker is art to his. They are all the same kind of thing esthetically, whether striking responsive chords in a bird brain, in the brain and feelings of an esthetic Australopithecine, or in those of his human descendants.

We have comparative anatomies and physiologies, and a theory of evolution that relates us formally to other living things. Why should we not have a comparative esthetics that relates us in feeling and behavior to other life? To amend the quotation from Professor Rapoport with which this chapter opens: What is needed is not a logical theory of man's physical and cultural evolution but an esthetic theory based on a simple

recognition of the arts. Man, alone of all creatures, from his beginnings has created cultures and conditioned his reflexes through his arts. The difficulties so far experienced in applying behavioral theory to man is due to the failure to see that the arts are the reflex conditioners that enabled man to create the emotionally conditioning systems that are his cultures.

In producing and experiencing arts, man found an evolutionary advantage. Changing by means of his arts into a highly sensitive, adaptable creature, he could then use his arts to replay, subdivide, refine, combine, and recombine emotional experiences. Once man had thus become man, once he had crossed from a preprogrammed instinctive creature to the artist-creator of himself, he could begin his long exploration of this turn of existence, this cultural refinement of being. A new kind of evolution—cultural adaptation based on freely created, noninstinctive arts—took over the species.

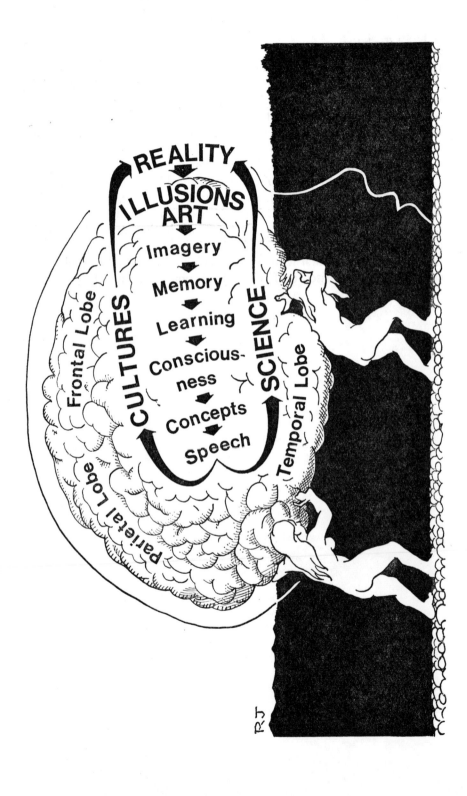

IV
THE ART-MIND

The arts enabled protoman to change from the long-range adaptations of instinctiveness to short-range cultural ways of adjusting to an environment. They provided the insubstantial scaffolding within which he built his unique cultural consciousness. His peculiarly human inner life owes to his arts. Without arts he would have no mind. Not surprisingly, the mind of prehistoric man—as is the mind of surviving hunting, fishing, and food-gathering man—was that of an artist. His interest in technology did not point toward the control of nature but toward the development of his social relations and his consciousness through the production of arts. After acquiring a minimal equipment for survival—a few simple tools and fire—he stopped his objective experimentation and refined his means of subjective control. He made tools with which to tattoo, paint, model, carve, and engrave. His interest in materials—clay, pigments, gold, copper, and other metals—was an artist's interest. He was concerned with his dreams and his group identity. He developed his individual and social subjectivity. He was more occupied with organizational experiments than with objective explorations, and the only means he had for organizing himself and his fellows was his arts.

Man's mentality is ultimately based on his sustained experiences of illusions. He could have found a controllable source of these illusions only in his arts. From the experience of these insubstantial art projections has come his mental imagery. With this ability to imagine, he could then create and hold abstractions in his mind; he could think conceptually; he could concentrate his attention in the absence of objective stimuli; he could manipulate and control his own motivations.

It has been suggested that man became most markedly different from other species when he acquired speech. Through speech, it was thought, he became rational. He then went on to writing, logic, and mathematics until he arrived at what scientists sometimes assume was his preordained goal—science. Evolutionist Charles Darwin, physiologist Ivan Pavlov, archeologist V. Gordon Childe, all great men and great thinkers, are among those who have advanced speech as man's first cultural or cultivating asset. Aside from the teleology which seems to have put objective science in the place of destiny or Divine Will, we are not told how a semi-ape could have produced a language without first having a

27

culture. In his Presidential Address to the British Association for the Advancement of Science, Lord Brain said man "has built up his society on the basis of language, and it is language which has made possible the unique complexity of social relationships, out of which have sprung, among other things, the scientific achievements of which I have just been speaking" (*Listener*, August 27, 1964).

What must be objected to is not the importance given to language in these opinions, but the omission of the arts and the idea of art from the thinking of these outstanding men. Such thinking simply overlooks the stubborn probability that language cannot have served as a primary link in social relations. Language came too late to bridge the gap between instinct-directed animal and culturally controlled man. True speech could only have come after man had somehow made the crossing from the instinctive to the adaptive. He could have made this transition by means of simple arts; and from art to organization, speech, and concepts, a direct line can be drawn.

Such esthetic expressions as the dance would have been early means of affective communication, prelingual "body rhetoric," evoking excitement in others and persuading them to desired responses. Once established, any such art would serve repeatedly or permanently as a primitive line of communication, at first perhaps carrying only emotional messages but potentially capable of carrying rational ones. The seventeenth-century philosopher Etienne B. de Condillac speculated that man's first attempts at descriptive reporting were in the dance. As lively pantomimes, he believed, these performances could have provided early man with comprehensive reenactments of happenings. The language of words, he thought, then arose out of the use of sounds and gestures in total mimicry.*

The first steps toward culture and ultimately toward abstract thought came when humanoid creatures deliberately projected and willingly accepted such designed illusions. Even today we see what undoubtedly are continuations of prelingual arts carrying their messages over language barriers. Westerners, easterners, northerners, and southerners can experience each other's nonverbal arts without speaking each other's languages. The "artistic mode" of communication, according to scientists J. B. S. Haldane† and J. D. Bernal, goes far back into prehistory. They also speculate that this may be prehuman, citing the "action-provoking" use of the artistic mode by the birds. Zoologist Robert Hegner reported that monkeys of the tropical American jungles communicate through

*In K. E. Gilbert and H. Kuhn, A *History of Esthetics* (Bloomington, Ind.: Indiana University Press, 1953).

†In J. D. Bernal, *Science in History* (London: C. A. Watts, 1957).

their gesticulations, through the postures they assume, and through sounds. Psychologist Lawrence K. Frank recently wrote: "Early communications were probably nonverbal, using a variety of nonverbal messages such as chants, dances, change of gait or stance, postures . . . facial expressions and varied tones of voice (which apparently gave rise later to articulated language)." According to zoologist Edward O. Wilson, "ritualization" is the evolutionary process by which a behavior pattern becomes an effective signal. Professor Wilson traces this to "displacement activities" in which a creature, frustrated by a rival, redirects its behavior from its intended object and its usual pattern in an apparently meaningless way. Instead of struggling against a strong competitor, it may attack a pebble or a blade of grass. The new behavior becomes a symbol: It is a more or less representational illusion of successful combat. Such behavior stops at ritual in the animal world. It goes on to art, and then to language and writing in the human world. "Redirected activities and displacement activities have often been ritualized into strikingly clear signals," says Professor Wilson, citing a concept originated by Julian Huxley.

The idea that protoman had speech was cogently criticized by Loren Eiseley. He objected that the assumption of such primeval languages would mean a "preadaptation," an adjustment made in advance of its preconditions. Preadaptation avoids the central question of man's origins by assuming the explanation of precisely what is unexplained. "The preadaptation or other explanation of the shift over from the purely signal communication of the animal to the linguistic activities of man," Eiseley says, "is left unexplained for the simple reason that no one adequately has come to grips with the problem." Early evolutionist Wallace "was correct," adds Eiseley. "The world of man is a flowing world of dreams and symbols which he created long ago and which will last as long as man is man. In no other world can he now live. But the key to the secret doorway by which he came into this world is still unknown."

The arts are the key, and the only key, to this doorway. They made man adaptive, unlocked his mind, and gave him his "open sesame" to the world of culture. Crude arts of various kinds served the purposes of organizing, conditioning, and message-carrying before there were any true languages. Since we still have arts that are independent of speech, we should have no difficulty in supposing that our ancestors had arts apart from speech and before the development of speech. With effective and dependable arts, however crude, the source of imaginative thought would have appeared on the biological scene at an early time, providing a foundation for our adaptive social life. With esthetic communication preceding logical speech, with emotional sounds preceding rational

sounds, primitive "preadaptation" is explained away. Just as, within historical memory, man's visual art led by way of pictographs to the rational conventions of writing, so protoman's or early man's emotional sound-making must have led the art-enriched mind to the artificialities of rational speech.

Art can account for the mentality behind man's consistent employment of tools, whereas the use of tools by animals that do not have adaptive arts has not noticeably enlarged their mental capacities. Where language fell short and came too late to make a brute into man, fire-making and stone-shaping, even if they were early enough, could not by themselves have given animal subjectivity the means of enlarging into human intelligence. Animal mechanics may be clever, but they are not thoughtful. The finch that uses a thorn for a skewer, the sea otter that breaks shells with a stone, the gull that drops tide-stranded clams from a height onto rocks, and the chimpanzee that strips a probing-stick with which to draw up nectar from ant and termite hills, do not show any other signs of enlarged mental horizons. The remotest ancestor of man at pre-art stages—if there were such artless stages—could no more have been a philosophizing toolmaker than were the apes. He could have trimmed and used a twig if it happened to be handy, as the chimpanzees do, but without arts and without the mental imagery derived from arts, we cannot account for his qualitatively different mentality. At pre-art levels, no creature could have the imagination that has obviously been created and enriched by the arts. No remote and uncreative ancestors could have been cultivated to a degree that would distinguish them completely from nearly related species before they had a culture. The evidence of the arts, from the ritual practices of early man to the fantastically rich esthetic works of recent and contemporary nonliterate man, and of literate man as well, points to the arts as the matrix of the unique human mind.

Protoman could create germinal arts because the physical basis of the arts exists unexploited in the sensory equipment of all animals. In other creatures, however, instincts preclude individual adaptability, and the possibilities of free arts remain undeveloped, as was noted in the preceding chapter. Along with the animals, man identifies objects by appearances and other impressions received through his senses. But at the same time and by the same means, he and the animals may also mistake an appearance for an object. On entering a familiar room, a cat will sometimes arch its back, spit, and retreat; a dog will sometimes growl or bark or raise its hackles at an appearance beneath a chair which is, in fact, nothing but a shadow. These errors foreshow art and the mind. In the momentary mistaking of an appearance for a reality, of a pseudo-thing for a real thing, a glimmering of imagination and a forecast of the arts have appeared.

A kitten or puppy will react to its own reflection in still water, as they and many birds react to reflections in glass. For a brief time the young mammals will paw or bark at the moving image, while birds will sometimes court or protractedly fight a reflection. Newspapers throughout the United States have made a standard spring feature of cock robins fighting their reflections in suburban window panes. Kohler tells of a dog alarmed at seeing a miniature stuffed donkey. The toy also interested a live, full-sized donkey. Darwin tried a looking glass on two young orangutans in a zoo. They at first gave their reflections the same affectionate attention with which they treated each other, but, in a little while, "became cross and refused to look any longer." Kohler's chimpanzees after being made acquainted with mirrors learned on their own to see reflections in shiny surfaces such as water or tin and were "permanently attracted" by them. The germ of the arts, of the mind, and of the imagery that underlies conceptual thinking is here, but, except in man, it remains germinal. Simple sensory misapprehensions do indeed point the way to thoughts and dreams, the way taken only by man. Kohler suggested that the lack of speech and "a great limitation of those very important components of thought, so-called 'images,'" prevented the chimpanzee from even beginning to develop cultures. It would seem rather to be the inability to project illusory images, the inability to create arts, that brought the mental development of the chimpanzees to a dead end.

Deliberate impositions on the senses of ancient hunters and pictorial illusions showing these deceptions have survived in cave paintings. Within the illusions were the representations of other illusions. Paleolithic stalkers or magician-dancers were depicted dressed in the horns and pelts of the animals on which they preyed. Models for these pictures have survived into modern times: Native Australian hunters still imitate the postures and hops of their kangaroo victims; American Indian hunters used buffalo skins as disguises and the moose call as a lure.

Professor Wilson says that "by ruffling their feathers or spreading their wings," birds, "create the temporary illusion that they are larger than they really are. Many fish achieve the same deception by spreading their fins." In this behavior and in the protective coloration of sitting hens and young fawns, in the camouflage of twiglike and leaflike insects, nature herself is artful. But these natural arts are inborn. They are not arts which can be used at will.

When a creature appeared that could imitate appearances or sounds whenever he wished to, and did so with deliberate ingenuity aimed at the control of the effects his imitations had on the nervous responses of himself and his fellows, it may be said that the first step toward the arts had been taken. And through the arts, further steps led toward cul-

ture, intelligence, and science. The creature taking the first step was ancestral to man. The unavoidable tendency of the senses to err led the way through the acceptance of illusions to our unlimited subjective adaptability and, eventually, to our powerful objective technologies.

Physical evolution shows us an ancestor of the primate line who was perhaps forced by changing circumstances to walk upright and so was freed—or compelled—to use his hands more than the other primates. Upright posture and the use of two hands instead of a hand-foot combination may well have led to other anatomical changes. But such changes could not alone have forced or fostered the development of greater intelligence. The sequence from hands to manipulations to ingenuity, and so to man and his mind, has been suggested. But the tailed monkeys have what amounts to five hands and have remained no more than moderately intelligent. Squirrels, raccoons, and other creatures have deft "hands." Uprightness of posture, from the ancient dinosaurs to the bears and kangaroos, has not been accompanied by very large brains; and as shown in the last chapter, the larger brain in itself is not decisive to intelligence. We can say, "No art, no mind," for art must have accompanied anatomical changes, social organization, and tool use. Of all earth's creatures, only man has fully exploited the adaptive arts, and ancestral man could have had, and must have had, arts at the most primitive levels of his existence.

In one hominid line, the doorway to the world of symbols and dreams was opened. A gnarled root that interested, pleased, or frightened an ape-man might have been carried about to interest, please, or frighten others. The step was small but the effect on the mind was enormous. Man perhaps went from noticing what things and what actions were emotionally evocative, to remembering, gathering, or creating them.

The regular use and control of fire, like the acquisition of speech, indicates a preexisting culture and arts. A flaming brand from the hearth certainly offered a defense against any night prowlers not already warned off by heat and smoke. But in addition to defense and to turning indigestible meat and vegetables into digestible foods, a fire at night in a rock shelter or cave would extend into the night the time for the display of arts. We may imagine our art-struck ancestors in some natural recess having their attention focused by the bright light of a fire amid surrounding darkness. Given wakefulness around a blaze, art can readily be made from moving shadows on shelter walls, shadows that magnify life and reproduce, distort, and abstract living forms. Such a nightly environment could advance early dance, pantomine, and theater. And it imposed a new mental discipline on primitive human beings, the discipline of concentration. By exploiting the brain esthetically, art brought

to *Australopithecus*, or *Homo erectus*, the ability to concentrate. Sustained attention to illusions and ideas was developed in this way, and to this degree, only in man.

In remarks on his work with chimpanzees, Kohler said that attempts to make one of his brightest subjects concentrate were met with stubborn inattention. "Nueva would on her own tie banana leaves into knots and plait straw through a wire mesh," he said. "I often thought she was about to begin a deliberate, though rudimentary, constructive effort, a form of manual craftsmanship, but she could never be induced to continue these efforts on any plan. . . . The slightest pressure toward anything stable and 'productive' extinguished her joy and interest at once." Darwin had earlier commented on the lower animals' inability or unwillingness to concentrate. "Hardly a faculty is more important to the intellectual progress of man than attention," he said.

Mental concentration is not easy, even for modern man. And it must be remembered that protoman was only potentially—not actually—different from the ape and the wild dog. Dawn man's brain, no less than his other organs, must have responded only to stimulations of some kind. In the literature of evolution, no motivation which would not also apply to other creatures, especially to other primates, has been presented for the early steps in the transformation of an animal into a human being. Such a moving force, of course, would necessarily be appropriate to early hominids. It would have to be so effective as to make our prehuman or early human ancestors drive their brains to the difficult work of thinking abstractly, which the orangutan and the chimpanzee have not yet begun to do. Our pre-*sapiens* ancestors must have felt and acted on needs and desires in the presence of actual stimuli that could be associated with satisfactions, as is still the case with most of the animal kingdom. These motivators of desire, which continue to operate at prehuman levels, were replaced in man by something that ultimately gave him the insights that now anticipate and control many events. This "something" must have come into operation before man had achieved rationality and perhaps before he could make fire and chip flint.

This "something," this replacement of actual stimuli, could only have been the germinal arts. The way to culture and the human mentality could not have been found except in adaptive arts. Animals are intelligent only as their reasoning and feeling coincide under real stimuli. If a stick and hanging fruit are present together, desire and reason coordinate; the ape brain may be stimulated to problem-solving by an excited appetite in the presence of the stimulus and such real objects as sticks.

Our children start on the prelingual level, as our ancestors did. Before we learn to project art-effects, we learn to accept and respond to them.

The inculcation of responses to representations and to facial, gestural, tonal, and verbal variations, the learning of when to be passive or active, calm or excited, is a part of every human being's history.

Man somewhere discovered a way of "moving" himself, apart from objective stimuli—else he would not think and act on abstractions any more than his fellow creatures do. He found a way of triggering his own reflexes in the absence of both fruit and sticks. In this he passed over from the instinctive to the art-conditioned, from herd to culture, and from reacting instinctively to behaving culturally.

In shedding his instincts, our hypothetical ape-man would have lost some of the inhibitions through which weak members of a species are protected from the strong. Conflicts between two male wolves or two male deer end when one surrenders. Instinct apparently causes the winner to accept the loser's submission or retreat. The obverse side of instinct-free man's adaptability appeared in cannibalism and shows up still in our murders and wars. With the weakening of inhibiting instinct patterns, the females in protohuman groups, for example, may have been hard put to protect their helpless young from the appetites or tempers of adult fellows. Yet on one hand the species survived and on the other hand the species, we know today, endlessly creates arts. The members of some deviating primate group, with the nursing females perhaps taking the lead, discovered the esthetic way to survival. Going very little beyond the apes, attention could be captured by voice tremolos, calls through hollowed hands, barks, howls, roars, rhythmic motions with grasses or branches, play with bright objects. From threatening animal mimicry to sexual invitation, a repertory of stimulants could rouse the emotions and channel them into socially acceptable rather than socially destructive activities.

The transmission from generation to generation of simple ritualized motives would be carried on through the young who witnessed and acquired the primal arts, a process that must have been difficult and uncertain. The labor with which we acquire and teach responses to the arts has had little attention, though it must be fundamental in every social group. Standard works on children's growth, such as those of Piaget and Spock, give little or no attention to the subject. Yet the effort of a small child to connect the kitten and the saucer on the floor with the kitten and the saucer in the picture is an effort to duplicate an enormous evolutionary step. Our plastic but still prehuman ancestors must have been made ready by the creation and acceptance of art for this change. The absence of art creation and readiness for such a change is clear in studies of nearly related creatures. In one experiment, a chimpanzee raised in a household as a child is raised carried its listening to the tick of a real watch over to a listening attitude toward a pictured watch

in an advertisement. She also pointed to pictures of beverages and ran to the kitchen to be given a drink. However, she does not appear to have originated or duplicated any artistic effects and although she scribbled a great deal, her drawings remained unintelligible.

Apes show little capacity for working with mental images and for conceptual thinking. Archeologist V. Gordon Childe noted that chimpanzees could solve problems if they did not have to go far from concrete situations. "What is distinctive of human reasoning is that it can go immensely farther from the actual present situation than any other animal's reasoning ever seems to get," he says. The ability to think of something in its absence provided man with a way of representing or symbolizing a stimulus when it was no longer present, psychologist Norman H. Munn noted. This was "an important step in mental evolution" (*Scientific American*, June 1957).

The earliest arts pioneered the development of the mind through art-derived imagery, as the arts still do with the minds of infants and children. The ability of the human mind to carry illusions and to create them can be credited only to the arts. We are able to sustain imaginary conceptions because, with the help of arts, we have developed our minds. In the arts, we experience symbolically things that do not exist in the fragments or combinations presented by actual experience: A whistle may evoke the wind, a pounded drum may sound like a stampeding elephant; we meet creatures that are half man and half lion, bird, or fish. The art-prepared mind easily creates and accepts new combinations and new ideas.

A mental "image" may be more abstract than the word suggests. It can be a thought about an object without picturing it, or of a relation of things when none is visualized. An auditory or verbal concept, as in thoughts of sounds, numbers, or words, is mental imagery for which no visible original may exist. Man often thinks in these ways, but then, the thought-originating arts are not limited to the visible. The task of evolutionary speculation is to tell us how we got from monkey to mathematician.

With his arts, man became able to sustain his attention beyond the influence of ordinary stimulations. Among other primates, concentration seems to last only as long as the attention is held by present incentives. But man can continue a set course of activity in the absence of ordinary motivations.

The exploitation of this esthetically derived ability can account for early man's survival. A preliterate food-gatherer might be inclined, like most animals, to seek food only when he was hungry, to rest when he was tired, and to turn away from boring occupations. However, early man soon was superior to the brutes not only in his foresighted behavior but

also, and fundamentally, in his being able to conceptualize and concentrate. Due to his arts, he had an imagination that could hold and reanimate the images that served him as abstracted and sustainable motivations. Man's long prehistory was probably occupied largely in discovering and developing this essential social-cultural means of survival. And, as prehistory ended, man turned, by means of his adaptive cultures, from a free, if sometimes miserable, hunting life to one of monotonous work and confinement in his early villages and cities. In the agricultural and industrial revolutions, he exchanged his anarchic and romantic savagery for a more secure life of dull application, transforming himself from wild food-gatherer into disciplined grower, herder, and industrial worker.

Changes in the means and relations of production called on man to sustain monotony, to concentrate and work in spite of what an ape would have found to be unbearable tedium. From insectivorous tree-dwellers to ground apes to ape-men, there is a sequence of increasing plasticity and freedom leading to modern man. Our freedom is not absolute. It is the freedom of self-control. Sensitive and noninstinctive, we have submitted to esthetic-cultural controls that often make us behave like the social insects. This has been self-created and self-imposed discipline. It has been without gelding, as of work horses or oxen, and without the similar sexual neutralization of the bee and ant workers. In the absence of such physical and physiological changes, we nevertheless can accept behavior patterns that are at odds with any ordinary stimulus-reaction rules, because we have arts. Through the exploitation of arts, man helped himself toward the thinking which distinguishes him from the animals by making him capable of abstracting ideas of things, and he also discovered how to abstract his motivations.

In the most primitive of arts practiced effectively and repeatedly, man discovered how to abstract and sustain feeling. Long before he could read or write, and perhaps before he had much speech, he had learned how to store up reflex conditioners and motivators in his arts, which he could call up at will. These stores of experience, stimulation, and control were passed on from generation to generation. With them, man found he could arouse his own and another's desires. He could attract and repel himself and others. In exploring the possibilities of the arts, he found ways to obtain concentrated emotional expressions and responses. With the intensified illusions and the pseudoexperiences of the arts, man abstracted and protracted his feelings. Even at preliterate levels, he could abstract rational concepts, but he preferred to project these in art forms such as totems and myths.

To sum up, early man, using arts, could communicate before he had speech. His adaptive, esthetic means of communication had a wider

Mental power Realized

range than those of any other creature. With them, he could persuade and inform. His esthetic activities gave him increasingly refined feelings. His brain size and his mind expanded. His arts prepared him for thought. His consciousness grew with the social interplay of subjective experience in the arts and objective experience in the struggle for existence. As he became aware of his own creativity and of the means he used to persuade and inform others, he became conscious of his mental powers. Through combining the esthetically effective images, sounds, and motions he now held ready in his mind, he could conceptualize endlessly.

For ages, man's thinking was artistic. The animator of the arts presently created an animated universe. He knew the world first by feeling it. All things in his arts and in his life—stones, plants, animals, men, and myths—were experienced as one. They were interrelated and interchangeable. His speech, when he invented it, was emotional rather than rational. Until recently, it was always more poetic than prosaic.

In rivalry with the unpredictable assaults on his senses from the objective world, early man provided himself with the esthetic experiences that refined his feelings into emotions and "structured" the higher part of his nervous system. He was creating his mind. He was worked upon by bits of fur instead of whole cats, disembodied claws and teeth instead of whole bears, pulsing tom-toms instead of heartbeats and thunder. He was conditioned by auditory and tactile arts as well as by visual arts. He was able to have intense feelings induced by fragmentary representations, and with concrete references sometimes reduced to the vanishing point.

The abstraction of rhythms, tones, forms, colors, and motions was unavoidable in the arts because the creation of art is an abstracting act. The kitten in the picture is not a kitten; the voice of a reed pipe is no one's voice. Already one step from identifiable objective stimuli because conditioned through the illusions of the arts, man's store of art-formed emotions, his higher conditioned reflexes, gave him the symbolic elements with which to begin thinking abstractly. These, at first, vague emotion-symbols could be made to appear in the mind not only by overt happenings but also by imperceptible promptings, by subliminal objective signals, by unconscious bodily processes, or by associations. Man's ability to sustain his art-cultivated emotions without continuous stimulations led to his ability to think without direct stimulations and without clear imagery. Where imagery evoked feelings, feelings could in turn evoke imagery or the abstracted residue of images, for the process is associative and reversible. When we associate these feelings and these abstracted images, we are thinking. Rational abstractions, such as geometric figures and equations, now enable us to sustain conceptions and apply them as needed. Emotional abstractions long ago enabled our ancestors to sustain and apply motivational feelings as no other creature could.

Conceptual generalizations grew naturally out of the arts. From a particular kangaroo rendered in pantomimic art comes the invisible class of kangaroos. What the hunter catches is an individual animal. In pantomime or wall paintings, the same animal is becoming the abstract idea of its kind. Like the logician's abstract class, the animal in art has no concrete reality. Neither have "universal" geometric shapes and abstractions such as a right triangle and "white," nor the ideas of "hard" and "horse," on which Plato and his Chinese contemporaries pondered. Forms, colors, hardness, and such nonconcrete things as kinds of animals were with the artist as nonverbalized concepts for thousands of years before the dawn of civilization.

Early art figured in other ways in the subsequent development of man's powers of abstraction. There are, for example, conceptualized figures in the cave arts that contrast with the naturalistic rendering of mammoths, buffalo, and stags. The representational animals are sometimes accompanied by human figures that are not at all realistic. Some of these are so exaggerated in length or thinness as to be schematized or semiabstract matchstick symbols. Here, part of existence is seen realistically and another part is generalized or presented as idea. The cave painters obviously did not see all nature in an objective or naturalistic way, as has been suggested by some writers. A part of reality, the animal world, was depicted naturalistically. Another part, man himself, appears as an abstract concept. This points, however distantly, toward generality and taxonomic abstractionism. The artists who were realistically drawing the food animals, turned away from naturalism in presenting the correlative hunters. And with astonishingly accurate representations of animals are found unrealistic sculptured "Venuses" that are all breasts and buttocks. These faceless figures present all the elements of fertility in abstract and emphatic forms, just as the hunters and stalkers are reduced to swift-running, spear-carrying male symbols with masculinity frequently expressed in emphasized sex organs.

What was the significance of realistic animals occurring with abstracted or ideological human beings? The artists who could see and draw animals were certainly able technically to see and draw their fellow human beings in the same accurate way. Instead, they drew partly recognizable, but partly abstracted, *ideas* of their kind. In this art, men represented and conceptualized their collective interests. In contrast to the modelings and drawings of the horse and other food animals, these human figures comprised ideas of men rather than representing actual individuals. These depictions by men and women of themselves in art gained significance to the degree that they were unrealistic. They became symbols by being doubly abstracted from representations of single individuals to become ideas of collectives. While they were organizing themselves into totemic

clans of goat, eagle, or killer whale, people were also able to identify with the group symbols of an all-fostering mother and her swift hunter mate.

This abstractionism in art was a recognition by the ancient artists that man's own group existence had developed to the stage where it had become a major part of his environment. The persistence of totemism into the present shows that hunting-gathering man long preserved his identification with inanimate and animate nature. Nevertheless, the later replacement of the natural by the social setting, in which the social environment overshadows and more and more controls the natural environment, was anticipated in this ancient art. The rational mind which went on to the agrarian-herding revolution, and to the logical, scientific, and industrial revolutions, was prepared in the arts of the early Paleolithic or prelithic.

The long perspective of esthetics, going back to the origins of our cultures and consciousness, assures us that the art-mind, which has so long served mankind, must continue to serve today as science generates problems that science cannot solve. We must remind ourselves that art is fundamental and necessary work. We must see that all art until the advent of capitalism was popular and mass art, and that art must again become as integral to our cultures, as democratic—and as responsible— as it was during all but the most recent past. Art is the major tool by which toolmaking man survived. Art must be used by modern men to remake, as early man used it to make, man's cultures and his mind.

V
EARLY MAN
AND EARLY ARTS

The free, noninstinctive creation of art works was the leap across the chasm that separated culture-maker and brute. On one side were all the other creatures, including the apes; on the other was man. Dawn arts need not have been complex or difficult to execute. All that early man need ask of his arts was that they be moving—which is all his successors have asked to this day.

Then, as now, any materials would do to help create the art illusion, and the more easily workable, the better. The absence of art works surviving from more than 30,000 years ago, that is, the lack of "direct evidence" from the more distant past, need not make us any less certain that early man, like later man, was an artist. It is not necessary to uncover early Paleolithic or prelithic art to support this contention. Durability of the art material would have been no more a consideration for the very early art-maker than it is today for the art-maker among the food-gatherers of the Upper Amazon or the Australian desert. Hardness makes stone good for blades and points and incidently for enduring until an archeologist digs them up. The art-makers would naturally turn to more easily worked soft wood and clay. They would be concerned not with making things to last but to be immediately effective.

When we consider that art-creating man has been on earth for at least half a million years, it is not surprising that he could draw, paint, and model as well as the cave arts of France and Spain show he could. What is surprising is that any art from so long ago has survived. And perhaps the cave paintings survive only because a local or temporary peculiarity in ritual put them in caverns as much as a mile underground and, thus, saved them from atmospheric and other harmful changes.

Back through tens and hundreds of thousands of years, man has seen his world through his arts. He has tried to turn the world into his own kind of environment by interpreting it through his arts. Then he has self-creatively adapted to what he thinks is there. Both men and animals do this as far as they are able, the one inventively, the other instinctively. The instinctive arts are widely accepted as fundamental in nature, but the free arts have not received recognition as necessary to and therefore

as old or older than man. Even where the belief in a supernatural beginning for man has been given up, an idea that calls for nothing less than a special creation for esthetic man is prevalent. In effect, these "special creationists" say, "Art started only a short time ago, without any real precedent, unaccountably." Ignored are the speculations of Haldane and Bernal that man's emotional communications, which in application can only mean his arts, probably preceded his rational speech. Mircia Eliade also tends to this latter opinion. He writes: "The paleoethnological and prehistoric documents at our disposition go back no farther than the Paleolithic; and nothing justifies the supposition that, during the hundreds of thousands of years that preceded the earliest Stone Age, humanity did not have a religious life as intense and as various as in the succeeding periods." Where he says "religious," we may substitute "esthetic," since, given an esthetic theory, religion is obviously a by-product of esthetics—an idea to be elaborated later on. But emotional communication and religion apart, the art-maker is generally given a late and miraculous advent. Time, for man as the artist, is extended grudgingly. The universality of esthetics cannot be seen where the antiquity of man's arts is ignored or denied. Geology has pushed back by millions of years Bishop Ussher's biblical date of 4004 B.C. for the creation of the world. Biology has similarly driven back the origins of species. Man is now held to be no less than half a million, and perhaps several million, years old, further confounding a special creation for man and the antievolutionary opinions of such other Victorians as Bishop Wilberforce, who debated Darwin's theory with Thomas Huxley. The limits of man's art creation have, by contrast, been pushed outward only mile by slow mile, and backward, first by merely a few hundred and then by merely a few thousand years.

It is only recently that Europeans recognized art works by non-Europeans as "art." Darwin comments on "the hideous ornaments and the equally hideous music admired by most savages."

Note of this attitude was taken by three anthropologists connected with the Musée de l'Homme in Paris (UNESCO Courier, December 1965). "Before being accepted as great art, the works of the people [Mayans, Incans, Toltecs, Aztecs, etc.] who lived on the American continent when the Old World was unaware of its existence were the subject of the most outlandish judgments" (Henri Lehmann). "At first boldness of expression [of Oceanic art] shocked Western taste" (Francoise Girard). "The esthetic reassessment [of sub-Saharan African works] at the turn of the century led to the 'discovery' of hitherto disdained art" (Michel Leiris). In other words, the spatial extension of esthetics has been very slowly recognized as including the whole world.

And the temporal extension of esthetics has been just as slow. S. Giedion's study of the cave arts is entitled *The Beginnings of Art.* Why

"the beginnings"? In several museums, including the Museum of Natural History in London, cave art is described without qualification as the earliest of man's art works. J. Graham D. Clark classifies the female naturalistic "Venus" figurines (of the Gravettian culture, 18,000 to 22,000 B.C.) as "the earliest art," and writes, "as far as we know" the somewhat earlier Neanderthaloids "produced no art." "The upper Paleolithic . . . saw the birth of art," states André Senet. Geoffrey Bibby writes, "The Solutreans . . . had no art," and Hallam Movius says, "The oldest manifestation of art appears during the Aurignacian" (about 20,000 years ago).

At the same time, of course, rational man, the toolmaker and firetender, is granted primordial status. The scope for a scientific view of material and organic existence has not been merely enlarged, it has become almost limitless. The scope allowed to the esthetic view of existence remains constricted. Perhaps our unreadiness to accept strange emotive works as art stems from our experiencing, though not acknowledging, the organizational powers of the arts. Group loyalties, themselves the product of art-created cultures, may cause the rejection of strange arts because they convey alien motivations. Something certainly has prevented our seeing the esthetic continuum stretching back to early man and protoman, not to mention its connection with the limitless prehuman past. With the cave works, the arts are now allowed to reach back 30,000 years—and stopped there. Why there? The argument for the cave arts as a "beginning," which is an argument for the special creation of esthetic man, can be no better than were Bishop Ussher's arguments for his popup Adam. The evidence for abridging the arts is no better than the evidence "Soapy Sam" Wilberforce had for isolating man from the rest of life and matter.

Anthropologist Geoffrey Gorer has said that his fellow scientists shy away from the study of art in simple societies, even now that tribal arts have become esteemed esthetically, "on the ostensible grounds that esthetics was not susceptible to rigorous study and categorization" (*Listener*, January 25, 1962). Bearing out Gorer's criticism, anthropologist William Howells writes that "we know absolutely nothing about ancient man, throughout most of the Ice Age, beyond his bones, his stone tools, and a little about what he ate when he lived. The bones show that he was a different animal, and not like us. We have absolutely no justification for making assumptions as to what went on in his head." And a footnote adds: "Toward the end of the Lower Paleolithic we have Neanderthal man with his grave offerings and his bear-skull shrines, but they do not prove that the afterlife, or animal souls, were the first supernatural ideas; they only indicate he held beliefs found also among American Indians." And in other writing, Howells says: "The Mousterians were without art, but they must have had religious ideas." But speaking of an earlier Nean-

derthal culture, an equally eminent anthropologist came to a different con-
clusion. Writing in 1923, Clark Wissler, then curator of anthropology at
the American Museum of Natural History, said that the (Neanderthal)
Acheulian's "perforated shells and stones are eloquent to the arche-
ologist, for they speak of art and dress complexes."

And the pollen grains of flowers speak even more eloquently to
anthropologist Ralph Solecki who reported that the recently recovered
remains of a dead Neanderthal, buried 60,000 years ago, were found
to have been decked with bright blossoms. Grape hyacinth, bachelor's
buttons, hollyhock, yellow groundsel, yarrow, and several other species
have been identified by Mme. Arlette Leroi-Gourhan, paleobotanist, who
said, ". . . someone had ranged the mountainside" gathering the flowers
for "the mournful task." This consciously artful, ceremonial interment at
Shanidar, in what is now northern Iraq, was performed, according to
Professor Solecki, by people of the Mousterian culture which "flourished
between 125,000 and 45,000 years ago." Another anthropologist reports
an art-directed burial by Neanderthals, this time in Lebanon, and not of
a man, but of parts of a deer, "dismembered ritually some . . . 50,000
years ago [with] red coloring of the bones." Scientists had previously found
"evidence of Neanderthal ritual treatment of the bear, but this was the
first involving a deer" (*New York Times*, May 10, 1974).

Scientific caution and a negative attitude to the arts may, after all,
come to the same thing. Both exclude esthetics. Howells says we know
something about early man's hunting, fire-making, and toolmaking, but
we know next to nothing about his interior life. This is saying, in effect,
that we can know the primitive scientist but not the primitive artist.
Surely, the reverse would be nearer the truth, for we can unhesitatingly
project part of what we know of art today into the past. Grave offerings
and bear-skull shrines, in addition to shell and stone beads, tell us of a
humanly developed culture—which owes to humanly developed arts. It
is legitimate to point to Neanderthal's successors in the human line who
have continually created arts in ornaments, beliefs, and rituals, wherever
and whenever these human beings existed. The richness of *sapiens'* be-
liefs and subjectivity are due to his arts. Since Neanderthal had similar
beliefs, he also must have had an imaginative subjectivity and arts pro-
portionate to them. Such things as supernatural ideas and religious be-
liefs are esthetic by-products, whether originating in the Paleolithic, or
before or since. They persist in relation to arts in every great city of the
modern world as well as in Indian encampments.

The bear-skull shrines suggest totemism which is a characteristic of
tribal societies. Each subdivision of the tribe, that is, each clan, is asso-
ciated with some plant or animal, or natural phenomenon such as thunder,
which is the clan's particular totem. The clansmen regard themselves as

akin to their totem and descended from it. Edible species have been chosen as totems in the great majority of cases, which gives us "a pretty broad hint," according to George Thomson, "that the origin is connected with the food supply." Among the Iroquois, the bear, deer, wolf, snipe, beaver, turtle, and eel were clan symbols, as were the ass, lizard, dog, goat, bear, sheep, pig, and calf among tribal Romans.

Early arts, then, often related to foods. This is what would be expected among food-gatherers. Their arts stimulated and directed their efforts. As the process succeeded and the population increased, art symbols were also used to subdivide growing organizations into clans within enlarged tribes. This form of organization has survived within memory among Australian and American aboriginal peoples.

But the persuasive arts obviously go farther back than clan and tribe. Thomson, V. Gordon Childe, H. G. Wells, and others settle on a "horde" for "farther back," which seems to suggest formlessness and even chaos. This, like the "special creation" for esthetic man, bypasses many awkward questions. In order to survive under any threat of extinction, noninstinctive, weak man would have had either to revert to brutishness and instinctiveness—that is, to a more rugged physical form and prefixed patterns of behavior—or to condition his reflexes and organize. His only means of doing the latter at protohuman levels were the arts, just as the arts were his first adaptive means of communication and the source of his strange beliefs.

Art-schooled man can believe anything and, within his beliefs, ignore or encompass anything. According to Danish anthropologist Kaj Birket-Smith, an Australian tribe divided existence between the totems of the red and the gray kangaroo. When the modern world intruded, airplanes were put in the red kangaroo totem, and trucks in the totem of the gray. However, if we were to accept the idea that men regard themselves as actually descended from the animals and plants and even from inanimate objects, we would do less than justice to the common sense of a creature that can go readily from reality to make-believe to belief and back again. We would not understand the origins of belief and would not distinguish between logical and esthetic ways of apprehending reality.

While primitive man did not have a theory of organic evolution or a science of meteorology, it does not follow that he rationally "believed" that animals founded clans or that a god caused thunder. The way that human beings believe in their arts and the way they believe anything at all will remain obscure as long as the nature and functions of the arts remain obscure. There is a common and mistaken notion that beliefs begot the arts. The opposite is true. It is the arts that generate our beliefs and our ability to have beliefs.

That totemic and animistic beliefs were derived from totemic and

animistic arts is much more credible than that arts were derived from man's mistaken ideas about himself, the animals, and matter. The "irrational" suggestion that such arts are nothing more than reflections of a groping rationalism gives a priority to reason throughout the backward Stone Ages for which there is no evidence or reasonable support. And the corollary, that preliterate emotive works derived from mistaken reason, from fantastically false ideas of objective reality, is even less satisfactory. It makes a fool of man until he became a scientist. It neither explains the arts nor explains them away. We are left to connect a supposed cause, a primitive and mistaken rational objectivity, through a complex of unlikely beliefs that came from nowhere, with the end result in art works that are supposed merely to illustrate those beliefs. This omits the observational powers and good sense—as well as the arts—of preliterate humanity.

The history of logic itself presents objections to deriving belief and the arts from ignorance. To describe a state of negative rationality, to project an approximate definition of what is not known, such as man's ancestry or the cause of thunder, is a sophisticated ability. Logic is hardly as old as writing. The concept of the mathematical zero did not appear until letters and numbers were well developed. Early man did not have the algebraic x. There undoubtedly were many things he did not understand, such as animal migrations and changes in the weather—which even today are not fully understood. But it would be unreasonable to expect him to classify unknowns when he had no means of conceiving of and communicating abstract rational negatives. In all probability, he had no practical motive for doing so in food-gathering cultures.

It was more natural for early humanity to fill the unknown with the emotionally interesting projections of the ancestral bear and the thunderbird and, later, the hero and the manlike god. All imaginative anthropomorphism carries a primitive sense of evolution and relatedness. For the deviating species, cultural man, the alternative to an art-populated universe was excommunication from life and alienation in a fearful unknown. The enormous gaps in what we now recognize as objective knowledge were filled by early man with the organizationally useful ideas of animism and totemism. These would soon become familiar and would make the void approachable. Tribal man made an effort through the available esthetic means to interpret the environment in the least uncomfortable terms.

The arts were indispensable for man's social conditioning. The control of relations within the group was (and still is) a prime responsibility of the arts. While the arts schooled man especially to cooperation and emotionally effective attitudes toward the food sources in the environment, at the same time men tried to assimilate the whole world through

their arts by naturalizing everything into their cultures and into their clans and tribes.

Man can believe in what is not present and in what does not and perhaps cannot exist. We are able to believe as we do, and to believe so extravagantly, because we first believe in our arts. The arts teach us to believe abstractly and culturally. It does not follow that man must mistake his experience of his inward-directed arts for experience in the objective world. It sometimes happens that he is so deluded, and that is the essence of primitive magic, religions, and class and race ideologies, as well as of human psychopathology. But normal children readily go out of as well as into the make-believe world of the arts. Common sense about man's whole existence is confounded where it is thought that primitive belief necessarily mistook art for reality. By extension, we would require classical Greek sculptors and playwrights and their audiences to believe rationally in the mythical subject matter of their arts. We might also suppose that Leonardo, the pioneering scientist who speculated about fossil sea shells found on mountains, believed objectively in the "holy pictures" that he painted; that the atheist Marlowe objectively believed in Dr. Faustus's magic; that the mathematician Dodgson objectively believed in Lewis Carroll's talking rabbit.

But belief—acceptance of the experiences of art—is of course essential to art. Disbelief in a work of art makes it nonexistent—as art—for the nonbeliever. Our Victorian forerunners did not experience primitive or very early historic art works as art. Fortunately for Euro-Americans, a few sympathetic travelers and anthropologists, moving with changing times, have brought us some of these supposedly alien art experiences that, after all, helped make man into man. Through them, we can dimly relive our self-creation. And, perhaps, before the still-living arts of food-gatherers, hunters, and simple agriculturists and animal breeders have vanished altogether, we can reinstate the continuities and the culturally valuable elements of our past.

We can, for example, share at a distance some of the bear-cult drama of the hairy Ainus. These preliterate white people of northern Japan revere the bear, as did the ancient Neanderthals. The Ainus hunt out a cub, anthropologist Edward Weyer, Jr., says, and bring it up as one of themselves, nursed at the human breast while young and given the freedom of the community until it is so large that it has to be caged. When full grown, it is killed in an elaborate ritual, with apologies and mourning. This whole art production has great spiritual and emotional importance for the Ainus, since the bear has become one of their children, one of themselves. He is a herald who, in death, will carry messages to the Ainus' gods and deified ancestors. After the lamentations, the people make a sacramental meal of part of the bear's body. Then there is dancing

and singing and sake drinking; after the feasting the bear's skull is placed in a row with the skulls of other bears, earlier emissaries to the spirit world.

For the puberty rites of an aboriginal boy in Australia, a holy ground is prepared. It is a complex ceremony from which women are excluded. There is circumcision and other ritual bloodletting, and enactments of tribal myths in which the performers impersonate their ancestors. A monotonous, insistent chant, rising and falling and accentuated by a rhythmic thumping of boomerangs on the ground, has a hypnotic effect. Initiation to manhood status may last as long as four months. For some, this is celebrated at a holy place where an ancestral snake of monumental size (sixty feet long) is painted on the face of an overhanging cliff. In one day there may be five or six ceremonies, with more blood, ordeals, chanting, and practice in memorizing and reciting the repertory of tribal lore. There are song-dance performances in which the words are accompanied by concerted actions and pantomime. The poet-choreographers who create such works are held in high esteem. Outside observers report that the sequences of ritual and recitation, and the formal movements of costumed actors which these artists create, have a powerful emotional impact on the participants in this corroboree.

Among the Fuegians of far southern South America, artistic rites also occupied a number of days. Songs, which conveyed myths and perpetuated traditions, were dedicated to birds and plants. The effectiveness of the rites is testified to by a mid-nineteenth-century Christian missionary who complained that these ceremonial occasions "were times of great disorder and license." Chaos and sin in one culture may be esthetic fulfillment in another.

The Eskimos' chief performing artist and religious leader is the ankagok, a wizard. Though tied up, he seems to his audience to be able to fly about in a darkened room, sending messages in a falsetto voice from the supernatural sphere. In the closing performances of Navaho religious observances there are clowns, torch dancers, and magician-priests who swallow arrows and make corn and yucca grow magically within half an hour. Sand paintings are central to these rites. They are created ceremonially with chants and rituals. They are sometimes as much as twenty feet in length, requiring the work of many men, and are swept away as the ceremony ends.

For the Bambuti Pygmies of the Congo, the soul of the forest is voiced in the molimo. This voice is produced physically by a long wooden trumpet, but it transcends its instrumentality. From among these forest-dwelling hunters, an inspired performer makes the song of the forest sound in the night, now on one side of a river, now on the other, now with a gentle, lowing sound, now with a falsetto and again with the growl of a leopard. Alongside their fire in the camp, the men sing songs of praise to the all-

providing forest, and the *molimo* answers faintly, distantly. Then with a burst of sound, the *molimo* comes out of the darkness, perhaps surrounded by a dozen attendant youths who dash close-packed through the clearing. Or, preceded by a pair of young male torchbearers, the *molimo* may attack the fire, setting the older men off in a frenzy of dancing among the embers which have been scattered throughout the village. With martial blasts and accompanying chants from the men, a last slow and majestic circuit is made by the *molimo* around the darkened village camp, and the concert-ritual is over.

The sacred musical instruments of the Piaroan Indians of tropical South America are tubular and conical spirals of bark, bamboo tubes, trumpets, and flutelike pipes, as well as various pieces of wood. When a group of performers enters a small dwelling, the volume of sound makes the air seem unbreathable. There are throbbing bass organ notes and high-pitched sweet, harmonious melodies. Then, in a larger temple-hut, a nightlong litany is carried by male voices accompanied by maracas, on and on for hours, flowing into the forest and the world beyond until, as one European visitor said, this art finally overwhelmed him, surmounting the obstacles of his white body and white understanding.

All our later art forms were foreshadowed in prehistory, from the mockingbird's throat and the stamping dance of the chimpanzees to the pygmy *molimo* and the magic flight of the shamans. Drama, song, painting, costume, instrumental music, fantasy, games, ordeals, rituals of death and resurrection—all were present, at least in germinal form, in the ages of stone and of protoman. Wherever historians, archeologists, and anthropologists have found more than a few flints, some charcoal, a few teeth, or bits of bone—evidence that there man has existed—they have also found evidence that there man has had arts in some form. The observations of explorers who have seen primitive man alive, and the few extensive recoveries of art by cave-crawlers and diggers, have invariably shown the arts and man bound together.

With justice, then, we may call man the artistic species. Where theories of man have neglected the place of the arts in his makeup, they have lost part of the human subject by leaving out an important fact *about* man and his evolution, and one of the most important things *to* man.

VI
THE ARTS CONTRADICTED
BY THE FOOD-PRODUCING
REVOLUTION

In the light of the technological revolution taking place today, the technology of prehistory looks like social slow motion. British archeologist Stuart Piggott has distinguished between new and old societies as "innovating" and "conserving." The terms are accurate but not enlightening. Archeology has long since showed us that preliterate groups changed slowly, and we know that contemporary societies are changing rapidly. Why is one kind of organization conserving and the other innovating? Was man's Stone Age-long conservatism unintelligent, and, if so, what made or kept him so dull? Or do we think him slow simply because he lacked our modern technologies and our scientific rationality—unimaginable in prehistory and irrelevant to art-dominated tribal man? The dialectical view of the arts and the sciences assigns conserving characteristics to the arts and incessant innovation to the empirical sciences and scientific technologies.

Art-dominated social groups are slow to change because the arts deal with being and continuity, which do not change or "progress." Science-oriented groups are constantly innovative because science, seeking to measure and control objective nonhuman nature, must repeatedly break with the ideas and beliefs of the human past, including the past of science itself. Science measures and defines, remeasures and redefines, and forever discovers things that seem to be new. Art conserves the values of the past, brings them into the present, and projects them into the future.

"Primitive man has always been extraordinarily conservative. . . . The most primitive of peoples have the most ancient of art styles," says anthropologist Douglas Fraser. While the arts have been conserving, they also have borne within them the seeds of their opposites, the sciences. Long anticipating the sciences, the arts have always been experimental, especially in their attitude toward audience response. No performer remains for long unaware of his public's reactions to his art. However, in preliterate cultures generally, the unchallenged and uncontradicted arts developed powers of intimidation with which the artist-priests and artist-

51

magicians imposed desired reactions on their captive audiences, rather than allowing experimental—or dissident—variations of response.

Tribal man would not question his arts, or the idea of magic that stemmed from them, because he had no contradictory rationalism. His choices were between reacting to the established arts and not reacting at all; between holding conventional beliefs and having no beliefs—that is, he had a choice between something and nothing, which is not a genuine choice.

If the arts, which must from time to time in early ages have been experimental, became arbitrary and perhaps even tyrannical, then when the food-producing revolution occurred, the change must have had a shattering impact on fixed tribal cultures. This revolutionary breakup of old art-dominated ways of living may tell us why the initial food-producing period in the Middle East, from 8000 to about 3000 B.C., seems relatively barren of arts. The ancient art cultures were specifically contradicted by the new cultures in a presumably fierce and vehement negation of primordial arts. This would, by the nature of the contradiction, stimulate great rational advances. These were realized in the revolutionary technology that man began to use 10,000 years ago. Logical advances were probably the backlash from the released tensions of esthetic conservatism.

The food-producing revolution of the Neolithic Age, the cultivation of food plants and the breeding of animals, must have cut across every habit and belief of man up to that time. The child of nature now found himself bound over to a garden or flock. A garden became fenceable property; it was objectively measurable. Sheep in a flock were countable. Man had to plan and keep time, count and measure as he had never done before. The free gatherer became a toiling producer. Technical innovations led to new developments in reasoning. There was need now for more than stone points and fire. There was need for tools for objective use, in addition to the lamps and gravers previously used for subjectively oriented art creations.

Man's means of production reflects the objective world to the extent that his tools are of rational design and deal more or less efficiently with the problems with which he has to cope: Arrow points tell of the hunter and his untamed quarry; the plow, the halter, and the gelding knife speak of the food-producer who has nature partly under control.

The way in which man applies his means of production constitutes his relations of production. Even today, in our Age of Science, these relations concern more than efficient coordinations. The relations of production among the prehistoric shell-diggers who left great middens on the oceans' shores, and the relations of production of the workers in gigantic steel plants, both embody the peoples' communal inwardness from which they

look out upon the objective world. Although aimed at efficiency, at getting the most work done with the least effort in the least time, the relations of production are also oriented to value-determined ends, to emotional adjustments and satisfactions within the group. The relations of production are primary in all social relations, and man's emotion-controlling arts occupy the key position in the determination of human relations and human values. The arts reflect the material and social conditions from which the arts spring and against which they have implemented the struggle for mastery of those conditions.

While the evidence of man's early means of production survives in stone tools, the evanescent evidence of the relations of production through which Stone Age human beings exploited those tools has vanished except for a few surviving art works and indications of art. The only knowledge we have of the doomed hunter-gatherers' social relations is what is preserved for us in the arts of such peoples.

There is no evidence that *Homo sapiens* was at first much superior to the members of the *Homo erectus* species in technology and rationalism. The more than 50,000 years of *sapiens'* technological conservatism is evidence to the contrary. That is to say that in the whole Paleolithic man did not radically improve his means of production. As for his relations of production, a great quantity of art evidence indicating the creation of high and remarkable cultures in the late Paleolithic has been found in the last century. A number of these works, carved in horn, modeled in clay, engraved or painted on the walls of caves, have survived from some 20,000 years ago. In the caves of southern France and Spain and elsewhere, art works appear in such numbers that we can get a genuine insight into early man's motivations and social organization. And, most significantly, this evidence is *art evidence*.

Judged by their *means* rather than their *relations* of production, by their food-getting tools rather than their arts, the sapient new varieties of our species cannot at first be rated much higher than Neanderthal; indeed, not much higher than most of the animals. All are food-gatherers; all are more or less blindly dependent on the bounty of nature. By comparison, the fungus-growing, herding, and city-building social insects had long since gained a true economic superiority. Man's prerational economic stage was much longer than the few millennia through which he has existed since the herding-agrarian revolutions. Before that, his tools merely extended his abilities as a hunter, fisher, root- and fruit-gatherer, and cook. These skills of *sapiens* were not a new, rational means of production, and they alone could not have made him a notably higher animal. And to the extent that food-gathering is work, all animals do the same kind of work, often with more than man's efficiency: compare the wolf at the chase, the otter at fishing, the chipmunk at digging.

The evidence of the arts strongly suggests that what led to the food-producing revolution in the Middle East was not rationalistic changes in the means of production but contradictions within the emotionally controlled relations of production. These could have been expressed not only through possible tyrannies of art, as mentioned before, but also through purely organizational adaptations made on the unchanged base of man's primitive, food-gathering means of production. The prehistory of modern man, between the disappearance of Neanderthal and the advent of the food-producing revolution, must have been an interval during which the possible improvements in productive relations of food-gathering and hunting societies, based on Stone Age food-getting means, were explored and perhaps exhausted. The numerical increase and diffusion of *Homo sapiens*, a physically unimpressive creature, during this interval, despite continuing Old Stone Age technology, reinforces this speculation, as does the evidence of feverish art production. There is nothing more prominent and more significant in the background of the revolution that later pioneered food-producing and civil life than the art activities that preceded by thousands of years the rational leaps of the food-producers.

The making of human culture is a continuing process involving contradictions. The culture created by the food-producing revolution was a rationalistic contradiction of art-dominated late Paleolithic culture. This contradiction is made evident in the abstract art of the food-producing era, art that survives in pottery. The shift to this abstractionism reveals the contradictions in man's previous existence where the hunter-gatherer's limited means of production did not keep up with his social organizations and with his elaborate and artful relations of production as expressed in his arts of animism, totemism, and myth.

Overextended esthetics began to give way to logic—as today overextended science, and its logic, must give way to resurgent esthetics or face, as man at the end of the Paleolithic faced, extinction. Contradictions between high esthetic developments and low technologies have worked to the same logical ends everywhere in the hunting-gathering world. The course of the American Indians from tribalism to monumental art and the logic of pictographs and calendar-making astronomy, on the base of their food-producing revolution, shows this esthetics-logic sequence. Yet in Indian America, the substitution of metal for stone, the use of the draft animal and the wheel were not achieved by the food-producers. The accomplishments of the American Indians without these technological advances underline the idea that progress out of the Stone Age was not motivated entirely by changes in the objective environment which led to technical innovations. The subjective forces of esthetics were also at work.

The antecedent of the rational food-producing era, then, was the esthetic Paleolithic. The art-richness of the hunter-gatherers' cultures was the thesis to which the food-producing revolution was antithesis. From some 25,000 years ago, there is evidence of a high specialization: the works of what must be called early professional artists. This art was produced in such quantity and was so widely distributed as to indicate that very much more must have been produced and lost. This prodigious creation of art can be accounted for only by supposing that an organized community permitted and encouraged the learning of this difficult skill, and to a considerable extent supported the journeymen of the arts.

The graphic and plastic representations of woolly mammoths, rhinoceroses, and buffalo are found in the depths of caves where they were executed—with astonishing precision—by the light of torches or small stone or clay lamps which have been found near the art works. It is pardonable to mention again that these early men developed good art-making tools while continuing to use traditionally chipped stone in their struggle with the objective environment. These Paleolithic art-workers lived in food-gathering economies where the accumulation and storage of surpluses were not possible. Yet these societies trained and maintained master artists.

The evidence of the caves shows art specialization much as we recognize it today. But there were no correlative scientific specializations. In truly primitive conditions, the complete separation of the sciences, of the objectively rational, from the arts was unknown. The effort to separate rationality from emotion, to develop logic, had not yet been made consciously. There was, of course, no writing. There were few precise measurements, no mathematical analysis, no coldly factual reports which trade for profit would much later make necessary. For early man, trading was an esthetic rather than a logical pursuit. It did not proceed in a businesslike fashion. If we take the examples of surviving primitives of the Pacific cited in studies of these peoples, goods changed hands as gift exchanges, not as sales. Trade was as much a means of social intercourse as of material transfer. A gift or an exchange was made to show friendship. Archeologist Colin Renfrew says that among the aborigines of north Australia, gift-giving was "the very heart of an important ceremonial involving the prestige and self-respect of all concerned" (*Listener*, January 27, 1972). Instead of logical reports, there were the nonverbal arts and the memorized tales, part fact, part fancy. Man still lived by fiction, fire, and flint. The contradictions between logic and esthetics developing out of the arts in prehistory point to the causes of later revolutionary changes. The triumph and failure of these arts show how the agricultural and herding revolutions came about, how the exceptions

to age-old rules occurred, leading after many centuries toward cities and empires. We can see how the counterspecialization of logic, after many additional centuries, culminated in the sciences.

In primitive cultures, everyone would share in practical (logical) and ceremonial (esthetic) work. In time, however, the emotive power of highly specialized art and the ability to produce it consistently would create a monopoly of master craftsmen in the art field and, eventually, would discourage or exclude the less proficient. Some of the cave paintings of prehistory show what seem to be artist-magicians. This suggests that shamans and priests or their prototypes were already present. Thus, while special creative activity, given conditions of social support, would increase, general creative participation would probably decline. This would generate tensions between specializing artist-magicians and the perforce practical specializers in food-gathering and hunting. If to this is added a catastrophic change in climate, with moisture and food animals retreating with the ice caps, the conditions are prepared for a revolution second only to the primeval art-creating, instinct-shedding revolution through which man began to create himself.

Any high specialization, such as that of late Paleolithic arts, leads naturally to—or generates—its own contradiction. The specialization—and monopolization through superior skill—of the erstwhile communal activity of art-working, an activity that related with unique persuasiveness to the associations of members within every early society, must have had profound effects on the traditional structure of the society. Perhaps the artists were the first truly privileged caste, the forerunners of priest-kings and capitalists. Thus they would have been the pioneers of the class societies which the later developments of surplus production raised to aristocratic and bourgeois levels. But in Stone Age societies, neither dependable, regular surpluses nor economically exploitative classes based on such surpluses could have existed. In the world of the cave ritualists, specialization took over at least two of the principal keys to the group subjective, the graphic and plastic arts—of which evidence has survived. It is also likely that other arts, long since lost, had been specialized in the late Paleolithic hunters' rituals. It is possible that, in times of good hunting, more skill and more social concern were committed to music, dancing, and the dramatic and narrative arts. Such commitments, too, might well have produced experts who would downgrade artistically inept individual hunters and who would tend—as did happen widely—to bar the nonhunting women altogether from some of the arts.

The loss of full creative participation in the arts must have turned the attention of the nonspecialists, now perhaps overstimulated by the power of these same arts, in another direction. Nonesthetic activities are also nonsubjective. Turning from the arts means turning toward the

objective world. If stimulated to activity by increasingly effective arts, and at the same time prevented by "lack of talent" or some other reason from working in the significant arts of their time, the excluded ones among the hunter-gatherers could work with zeal only in the alternate field—and in the only alternate field. Out of this dialectic there appeared —in a few places and in the course of ample time—the only possible contradiction to esthetic specialization, the specialization of technology and logic.

The prior circumstances of hunting-gathering life, the necessary character of the struggle that changed it, and the kind of societies that resulted from the agrarian revolution point again, as in the earliest self-creating esthetic revolution, to the probability that women were the leading spirits in this great change. The female food-gatherers, having been excluded from the hunters' magical art rites, could have focused the discontents and conflicts that presently were sharpened in Eurasia and northern Africa by the retreat of the ice sheets and the disappearance of the familiar food animals.

In all societies of the hunters, women were of secondary economic importance. Women were relatively immobile where mobility was at a premium. They were anchored by pregnancies and by dependent children. Just as the man was central in the hunters' economy, so he was the center of the hunting culture's arts and of its ceremonies and rituals. From inferior to outsider is not far. Women are still rigidly excluded from the secret hunting rites of the Stone Age survivals in Asia, Africa, South America, Australia, and Oceania. When boys are initiated by adult male hunters among the Australian aborigines and among the African Bushmen, great care is taken to guard against the profane female half of society. The magical hunting arts are concealed and protected from the women.

Jacquetta Hawkes opines that the cave artists sought for walls far removed from the domestic life that went on in the cave entrances. A large proportion of the cave art of southwest France and northwest Spain is found deep in the recesses of long, narrow, and often watercoursed caverns. Many of these works of art, as prehistorians have observed, are in situations that must always have been difficult to reach. The journeys required the negotiation of dangerous chasms, waterfalls, and small fissures. At Font de Gaume, there is a very small opening to squeeze through, and it leads to an almost inaccessible crevice. Here, an engraved lion and painted rhinoceros have been executed so high up and in such a cramped space that the artist must have worked while balanced on a companion's shoulders. Another site is accessible only through a chimney, below which are the rapids of an underground river and, beyond, further dangerous passages. Hawkes notes that the artists had first to explore

these perilous eerie galleries which were the haunts of the cave lion and the huge cave bear. They then set out to execute their works with no more light than was given by torches and by fat or blubber lamps. It is obvious, she says, that they were determined to reproduce their animal images far in the depths of the earth. "Further proof . . . is provided by caves such as Niaux." Here, "the artists have ignored a long cave passageway where the walls were well suited for painting or engraving." They started work at Niaux at a depth of nearly half a mile from the cave mouth.

It was women who challenged the hunter-artists' dominance. In pre-agricultural societies, the women were the gatherers who supplemented the main protein item of diet, meat. Women picked the fruits, berries, and nuts, and dug the roots. They gathered and winnowed the edible grains. As the men knew the animals, the women knew the plants, the kinds of soil, the habits and seasons of vegetables. They were the botanists being prepared in the womb of tribal society to come forth as heralds of the new, protoscientific, gardening way of life. And they were fated to be the gravediggers of the hunter's artistic and venerable, but decrepit, way— the way of the heroes of the bison clan, of the horse clan, and all the other totems. In the food crisis caused by melting ice and vanishing game, none but the women were in a position to challenge the immemorial customs of the hunt, which went back through Neanderthal to Pithecanthropus and perhaps to Australopithecus. No one else could risk offending the mana, the anima, the spirits of the totemic arts. No one else was prepared by the dialectics of adaptive cultural life to turn for main sustenance from meat to vegetable foods. No one else could then take the unthinkable, and probably sacrilegious, step of going outside the all-inclusive totem restrictions. No one else could have thought of planting seeds and tending the shoots—and then protecting them from animal and human gatherers.

The arts of the Upper Paleolithic hunters and their economies died together. Hawkes states: "It may be that the tendency toward conventionalization and the use of abstract or geometric designs apparent in the latest Magdalenian art shows that the great naturalistic tradition was already dying, but certainly it was killed at last by the spread of the forests (replacing grassy plains) and the ending of the old way of life." The time spread between Paleolithic art and the Neolithic art of emerging agriculture is great, running to several thousand years. But tradition in prehistory must have been as tenacious as time was long in order for toolmaking habits and art practices such as the bear cult to have lasted as they did. Consequently, there is nothing inherently improbable in seeing the Neolithic abstract and geometric art as a necessary contradiction to the stampeding, snorting, hairy and sweaty animal art of the earlier

hunters. Since revolutionary agrarianism was a logical supplanter of the highly esthetic hunters' establishment, it seems natural that all the old arts would be de-emphasized under the new dispensation. The radical women, the dissenters who had been excluded from the ritual arts, must have made themselves deaf to the drums of the witch doctors. They had to shake off the illusory arts of shamanism. They alone were in a position to awake from the spells cast by the conjurer and the wizard. Against starvation, amid the rich emotionalism of the arts, successful food production and the rationality that went with it stood out as decisively superior.

The ceramic arts came with planting. Pots had to be made watertight, insectproof, and rodentproof when ground meal and—above all—seed grain had to be stored. Nomadic hunters made do with baskets; pots would have been too breakable and heavy for them to carry. And besides, as Hawkes argues, it must have been Neolithic women who invented the processes of shaping and firing clay. The only "Neolithic achievement that is first-class art . . . is ceramic. . . . Cave art was created by men, while pottery was both shaped and decorated by women." As for the geometric styles in Neolithic art, anthropologists Boas and Weltfish have called attention to the right-angularity inherent in weaving and basketmaking. These crafts were likely to have been women's work and the transfer of geometric and abstract designs from these skills to ceramics would be natural and easy.

The agrarian revolution's contradiction of the culture of the hunters had many precise negative-positive aspects. Esthetic naturalism gave way to geometric abstract styles. The spacious "fine art" or mural painting gave way to the small "applied art" of pot decorating. Nomadism was replaced by a more settled life; caves and windbreaks were replaced by houses. As life-supporting tools, the spear and arrow were outmoded by the hoe. The male hunter gave way to the female planter as primary food-getter. The occasional fat cave "Venuses" became the omnipresent votive figure of agrarianism, the Great Mother. She continued as the Triple Goddess, Ishtar, Isis, Astarte, Aphrodite, and Venus, and reappeared as the Mother of God in Christianity. But the greatest turnabout was from esthetic domination and its conservatism to stupendous logical enterprise. After a stagnation which involved *Homo sapiens* as well as *Homo erectus* for many tens of thousands of years, there was first the food-producing revolution itself, with agriculture, animal breeding, ceramics, and weaving. Then came another spurt of technical advances in Asia and Africa with the establishment of urban life there. We moderns are still profiting from many of these later innovations. According to V. Gordon Childe, they include: artificial irrigation using canals and ditches; the plow; the harnessing of animals for motive power; the sail for boats;

wheeled vehicles; orchard cultivation; fermentation; the mining and fabrication of copper; brickmaking; the arch; glazing; the seal. Added to these by a later phase of the urban revolution were the use of bronze and iron, the solar calendar, writing, and numeral notation.

The last glacial retreat may have sparked these changes, but the conditions for the revolution were already there. Objectivity and science are the only expansive alternatives to subjectivity and art domination. Stagnation and social pathology are the results of the failure to make necessary logical revolutions. In this light, we can read Ruth Benedict's descriptions of the mad suspiciousness that once gripped the Dobu people of New Guinea, and the irrational status-seeking of the early Kwakiutl Indians on the northwest Canadian and Alaskan coasts. Benedict, using Nietzschean terms, classified these excesses as "Dionysian" ecstatics and opposed them to the "Apollonian" quietism of the Pueblo Indians. Like Piggott's labeling of societies as conserving or innovating, these terms are descriptive rather than vital. The esthetics-logic dialectic obviously is the key to these social phenomena.

The delay or absence of the logical revolutions tells us why some men remained primitive while, here and there, others were able to change. The arts of the ancient cavemen originally increased the co-operative effectiveness of their groups as, in their past, the arts of the socially sick Dobus and Kwakiutls and many others must have motivated healthy, objective group activities. Hopes of good hunting, tribal security, and numerous children were stimulated by the cave artists. But such hopes could not have been realized in objectively hard times by art works alone, however effective these works were subjectively.

To repeat, late Stone Age man, in the Northern Hemisphere, suffered through a series of crises as the climate changed with the recession of the last great glaciers. His food animals died out or retreated northward with the ice. The distribution of fodder plants must also have changed. In North Africa and western Asia, deserts may have replaced grazing grounds, and, in Europe, the grasses perhaps gave way at first to pine and then to oak forests in which the great grazing herds could not live. We may imagine the art workers responding with greater efforts to the crisis. But even if stimulating to their audiences, the old hunter-gatherers' arts could have no effect on the objective situation. A struggle for mere survival must have occurred in conditions for which the tradition of the hunt and its ritualized and now degenerate magic were not designed. The arts could whip up a hunting fever as before, but if the buffalo was gone, of what use was the best organized hunt? The objectively powerless arts turned inward upon themselves and their creators, as the arts in such circumstances have done repeatedly since.

It was at this time, as modern prehistorians have noted, that realism

in Stone Age art disappeared. But health in art is not a matter of appearances. True realism in art lies in its effects. The abandonment of accurate representationalism would not have been the most important result of decay and crisis in such an art-dominated society. The relation of the arts to reality, previously maintained through successful hunting efforts inspired in the audiences, was the greater loss when hunting itself failed. The hunters' cultures were turned back upon themselves in the major environmental change that took place throughout the Northern Hemisphere in the period between 30,000 and 10,000 years ago. The glacial retreat of this time marked the beginning of the end of man's Stone Age cultures.

Totemic arts served food-foraging man's tribal organizations. Totemism, in the opinion of George Thomson, directed the specialized hunting and food-gathering of the subdivisions of the tribe which were identified totemically. These art-directed special activities were early essays at scientific work. The witchetty grub clan of an Australian tribe, the bear, salmon, duck, seal, and bee clans elsewhere, studied their chosen subjects scientifically in an art context. They would observe the times of hatching or giving birth, of migrations and swarming. The syntheses of totemic art and science worked well for many thousands of years. It apparently brought increases in efficiency and in human numbers. *Homo sapiens* adventured or was pushed into every open bit of the earth. If there had been the pressure of rising population at the time of the last glacial retreat, 10,000 to 25,000 years ago, this would have made the food crisis worse. But the masters of specialized hunting and food-gathering could become the slaves of their totemic arts, as we know from the power of the taboos. The artist-priests could hardly allow the hunters of the goat clan to tame, breed, and unceremoniously butcher their sacred animal. Some of the rule of these early organizational arts still holds in caste Hinduism and ritualized Judeo-Christianity. The stimulating directives of totemism, Thomson thought, turned into their opposites, the taboos. The totemic cow, snake, thunder god, pig, lamb, dove, and fish are still with us in surviving religions and inherited arts.

Subjective man, belatedly, out of, necessity, became objective. The sleeper was rudely awakened. From within his art specializations came the contradictions between esthetics and logic, the subjective and objective. The contradiction of the arts by logic led precisely and directly to the specialization opposite to that of art—science, which here meant early agriculture and animal breeding. Without the pressure of outer and inner crises, this contradiction of esthetics would have remained unexploited in the eastern Mediterranean area, as it in fact remained elsewhere. It took hundreds of thousands of years to get from Australopithecus, if he was our ancestor, to *Homo erectus* and to *Homo sapiens*

and his arts. It took thousands of years for art-struck *sapiens* to mature the contradiction to his esthetics, a process which enabled and compelled him to take the next, the logical, step in his progress.

The ultimate dialectical effects of early artistic specialization and the requisite contradiction of esthetics by logic, though not always realized, were always at work. The development of agriculture did not take place everywhere that tribal men faced crises, but it did occur inevitably and unavoidably over widespread areas of the world. About 8000 to 7000 B.C., the agricultural revolution occurred in Asia Minor and North Africa, and perhaps independently in Middle America, according to recent archeological reports. Following this revolution, most of the few varieties of plants and animals useful to man were developed in Asia, Africa, and America. It is apparent that the deep force of contradiction was at work, drawing energy from within man's social and individual being, as well as from the environment.

It is easy for us to put too low a value on esthetic motivations in primitive men's cultures, as we put too high a value on rational motives that would make those men seem like ourselves. Primitive man did not have scientific precedents for isolating reason from emotion, or, perhaps more fundamental, the technological means, such as measuring instruments, for dealing with the objective world. Yet the preliterate ancients, in the opinions of H. and H. J. Frankfort, could reason logically, although they did not often care to do so, or begin to do so, until compelled by the extreme changes in their environment and by the contradictions developing within their art-guided cultures. The idea of food cultivation must at first have been shocking in a traditionally food-gathering culture; just as shocking as the idea of free enterprise was to feudal society a few centuries ago, and as the idea of socialized production is to some capitalists today. And if, as we have speculated, the arts had by that time degenerated through ritual to superstitious magic, the conflict around the new ideas may have been as sharp as such conflicts have been in historical times.

On one hand, we may dimly see a once-free world, a once-free nature, and human groups organized to hunt and gather its fruits. These human beings were conditioned by their arts to search for and take whatever they needed, and they were stimulated to enjoy this activity. How could they have become cultivators and herders? By age-old tradition and conditioning, the sight of a pig must have triggered reflexes for stalking and spear-throwing. In making the first small steps toward planting and cultivating, toward preserving a sow for breeding or a goat for milk, our Neolithic ancestors must at once have violated their own tradition of what was useful and right and inevitably have come into conflict with their orthodox fellows for whom all fruit was free and all animals were game. Some archeologists have suggested that seeds dropped accidentally

in the organically fertilized environs of campsites taught agriculture to women; and having to share with human beings the oases in the newly created deserts made less feral animals used to man's presence and thus tamable. It may well be that our ancestors learned to plant and herd in these ways. But in learning such things, man also had to doubt and challenge a well-developed, venerable tradition.

This diametrical turn, requiring so thorough a subjective and emotional reorientation, could not have taken place without, on the one hand, the "goad of necessity," and on the other hand, the developing contradictions within the cultures concerned. These contradictions would operate on the subjectives of some of the people to force them to choose between a food-gathering tradition, probably supported by magic and ritualistic arts, and the utterly unorthodox view of all objective nature implicit in the idea of cultivation. That these disparate views could co-exist in harmony is improbable. The food-takers would continue to take, openly or stealthily. But we are not concerned so much with early or late fruit thieves or cattle rustlers as with an art-dominated orthodoxy overthrown in a rationalistic and nonesthetic revolution.

It is interesting that when man ceased hunting other creatures as his principal source of food, he cut himself off from them. Those extensions of the hunter's self—his animal relatives, his brute ancestors, the art subjects of his totemism—became mere objects to the animal breeder. No longer free and wild, the domesticated creatures were no longer semi-sacred, no longer mysterious. Having mastered them, men were immeasurably superior to them. This enslavement of animals was a step, perhaps the first step, toward other kinds of enslavement. As the world of living things divided into Man and Others, man's psyche underwent profound changes. His new work—planting and reaping, breeding, milking, slaughtering—stood between him and his integration with the rest of life. He was on the road to his own exploitative alienation.

The Neolithic pioneers of food-cultivation and herding had no emotional-esthetic sanctions for their heresies. Hence the Neolithic revolutionists, putting behind them magic, ritual, the arts that were identified with the past, must have focused their attention on the objective reality with a concentration and a rebellious recklessness without which the total change of life would have been impossible and without which this early revolution would be unaccountable. Out of an age-long and finally decadent esthetic specialization developed its contradiction: the first, sustained, dimly logical but technically excellent, rational specialization—the food-producing revolution.

RJ

VII
MONUMENTAL ART MAKES THE URBAN REVOLUTION

Revolutions are power struggles. Those who make and those who resist revolutions use many kinds of force. The force under consideration here, the power of the arts, has not been given its due in the revolutionary context. As far as I know, the founders of the earliest cities have not been called what they obviously were, esthetic revolutionaries.

In the dialectics of human life, the hunter-gatherers' arts had been contradicted by the food-producers' technology about 8000 B.C. This protoscientific food-producing revolution apparently occurred first somewhere in the Middle East. Pragmatic farming and animal-breeding, and some of the technologies that went with them, ultimately displaced art-dominated hunting and food-gathering societies in most of the world. Then, beginning about 3000 B.C. in the same Middle Eastern area, a resurgent esthetics took over—and, in what V. Gordon Childe has called the urban revolution—apparently slowed the pace of technological advances. The attainments of the village agrarians were checked and then synthesized into new cultures organized by monumental esthetics around great ceremonial centers. Populations, which were increasing as the food supply increased, were brought together in the shadows of revolutionary monumental arts. These arts conditioned man for the next episode in the adventure of his existence. In their awesome presence, he passed from small-scale to large-scale social organizations.

As clearly as agriculture had come with a protoscientific revolution, urbanism marked a new esthetic revolution. City life was introduced through a regeneration of art domination. The new period was marked by the creation of great arts in ceremonial centers and by a slowing of the technological advances that had appeared with food-producing.

Like agriculture and animal husbandry, the idea of the urban revolution spread, or occurred independently, around the world. And everywhere that the urban revolution took place, it was focused in strangely similar new ceremonial centers. The unvarying characteristic of these centers was their presentation, in architecture, sculpture, and mural painting, of monumental, ideological art work. These were the first of the "hierarchitectitiptitoploftical" art forms whose impact is still felt by

65

readers of *Finnegans Wake*. The contrast in subject and size between
monumental arts and the typical art of the Neolithic villagers tells part
of the story of the new esthetic revolution. The new arts were not only
large, they were no longer principally involved with the female. Jacquetta
Hawkes refers to the older art as "the mute evidence of hundreds of
little clay, bone, and stone effigies of the Mother Goddess. They are
present in the prepottery Neolithic settlement at Jericho; they are present
in almost every cultural province between Sialk and Britain and from
Persia to Badari." Monumentalism went further geographically as well as
ideologically than the art of the Great Mother. It has appeared in every
habitable land mass, with the possible exception of Australia. The new
art carried a new ideology. In it, man began to reach imaginatively into
space with ideas of extension conveyed in large esthetic forms, and into
time with ideas of duration expressed in the most enduring materials
at his command. The universe was not flat, it was pyramidal like the new
societies, with a god-king at the summit. Man's pyramids and ziggurats
rivaled the mountains. They were high, long lasting. In Chaldea, astron-
omer-priests gave names and places to the stars. The Egyptian tomb
was the "house of eternity." Ancestor worship in China reached far into
the past. In Middle America, the Mayan calendar contemplated years
in the millions.

In spite of the apparent rationalism of these interests, they did not
resemble the small farmer's concern with time and space. The new urban
thinkers were more artistic than scientific; the city arts were custom-made
contradictions of the immediately preceding arts. From scattered huts
and hamlets, where weaving, geometrically decorated pots, and Mother
Goddess figurines were characteristic of the culture, man brought himself
to ceremonial centers composed of colossal works of art. In the esthetic
revolution of ceremonial monumentalism, the compelling arts of the
pioneering cities embodied a reversal of social direction, a complete change
in the motivating value system. This was the direct and total contradic-
tion of the practicality and frugality of the farm village and the herder's
encampment.

British archeologist Glyn Daniel, writing on the origins of civilization,
lists seven widely separated and largely independent instances of civiliza-
tions created by early food-producing peoples. These civilizations were in
Mesopotamia, in Egypt, in the Indus Valley of what is now West Pakistan,
along the Yellow River in China, in Mexico, Central America, and Peru
(*Listener*, December 1, 1966, to January 5, 1967). Daniel did not com-
ment here on the most striking common feature of these civilizations:
their building of monumental ceremonial centers. Yet it must be urged
that this monumental esthetics was essential to the revolution by which

men departed from village life and moved into urban life. To this day, according to some geographers cited by Daniel, eighty percent of the world's population continues to live in villages where the monumental esthetic revolution did not occur or regressed in defeat or social decay. In these villages, a conservative stagnation has set in such as that which held the Stone Age hunter-gatherers to a standstill for so long. And while not themselves urbanized, many of these stagnating villages and towns have become suburbs of cities, or resorts for city dwellers. Few, if any, such small communities have economic or political independence. They now serve villages-become-cities which have been modeled after those early urban centers, which were organized through the power of monumental arts. The art of the ceremonial centers and of the fully developed cities of the past looms as large over archeology today as it loomed so visibly over the city dwellers of ancient times. And the billion-dollar business and industrial centers of today cry out for revolutionary monumental arts to humanize their brutal glass-metal-concrete forms. They are colossal architectural blanks, pyramids and cathedrals in every sense but the important one: They have no artistic-ideological significance.

The early transition in human organization from village to city, from smallness to largeness, depended on inward adjustments as well as outward ones. These inward adjustments were made possible by the new monumental arts and their effects, rather than by any brand new technologies or radically new means of production. Archeology has shown us that by the time the great cities of western Asia and northern Africa were being built, that is, by 3000 B.C., the main technological advances of the food-producing revolution were already several thousand years old. The changeover from female to male farm workers, the shift from gardening to field agriculture, and the irrigation that made large-scale farming possible were already known to village agriculturists. But it is more significant for art theory and for understanding the esthetic animal to point out that even if all these things had been new, they could not have created the new religions, they could not have pulled the vastly increased populations together in new systems of belief. Only new arts could have done this and, as we know, arts appropriate for the tasks were being produced. Fustel de Coulanges notes that each ancient urban center, even when related to others by language and other customs, at first had its own god and its own ceremonies and rituals. In the Babylonian, Egyptian, Greco-Roman, Judeo-Christian, and Muslim consolidations of feudalism, these local esthetics were overborne by the arts of the great religions as well as by economic and military force. While economies and technologies were not changing radically, political alterations in the early urban communities were set forth most visibly in newly important male gods.

These were planted in the religions and in the reflexes of the people by the revolutionizing arts. The Great Mother was supplanted by Marduk and Osiris and many others, later including Zeus and Jehovah.

The arts, however, are seldom credited with the things they accomplish. Professor Daniel, for example, suggests that villages were drawn together through a vague process for which he borrows the Greek word cynoecism (attraction to a center). Beyond substituting a Greek word for English words with the same meaning, this does no more than note that cities appeared—leaving the arts uncredited for their appearance. Daniel also observes that the early Egyptians and the Mayans may not have had "true" cities. But they certainly had large populations gathered around centers of monumental ceremonial art. American archeologist Sylvanus Griswold Morley estimated the population density in the area surrounding the fourth-century ceremonial center of Uaxactun, Guatemala, to have been about the same as that of twentieth-century New York State. And another American, Frank C. Hibben, estimated that the pre-urban people who created the monumental-ceremonial Temple Mound at Cahokia, near East St. Louis, Illinois, were as numerous as the urban people of East St. Louis today.

In trying to account for the change from village barbarism to city life, the achievement of writing is sometimes mentioned as a key element. But Daniel's list of seven early urban centers contains some nonliterates: The Incas and their Peruvian predecessors did not have writing. These peoples, the Mayas, and the city-builders of pre-Columbian Mexico, also provide exceptions to a thought, mentioned by J. D. Bernal, that it may have been the cooperation required for flood control among peoples cultivating river valleys that brought about the shift from dispersed social units to larger aggregations. Another exception to this idea is Jericho, perhaps the most ancient of all walled towns, which began to grow around a spring rather than a river, perhaps as early as 7000 B.C., according to Hawkes. Taking art, not technology or protoscience, as the force making for cynoecism, it may be repeated that the wheeled vehicle, the plow, and the domesticated beast to draw them were all missing in ceremonial-city-building, monumental-art-dominated ancient America.

"Nothing but profound faith in the utility and necessity of their religions, along with the emotional satisfactions derived from their religions, could have given these peoples the strong propulsions . . . to carry on the enormous work of construction and to maintain it from age to age." John Collier was speaking here of the Mayans, but he might have been describing any other early monument-builders who employed the arts to create the religions which drew them out of village isolation into city-states and nations. Many things in the new ways of life—digging irrigation ditches in Sumeria, building dikes for flood control in Shang

China, creating the remarkable floating gardens of Mexico, terracing the mountains of ancient Peru—necessitated large-scale projects and disciplines that must have gone against the habits of homesteaders and villagers, not to mention the habits of once freely wandering hunters.

The scale of the change to city life, seen simply as immensity in the number of people brought together, required appropriate changes in politics, values, and motivations, that is, new relations of production. Brute force and enslavement have limitations as vehicles of change, especially when used on free barbarians or savages by their fellows. The necessary new relations of productions could be established persuasively, without self-destroying violence, through the arts. Creativity had to be released in order for the revolutionary urban workers to achieve all that they did. We know that the basic means of production had been changed in the earlier food-producing revolution, and those changes made possible the support of large populations. We also know that overwhelming art appeared when the cities exploited these basic changes. Where the revolutionary technology carried potentialities for great increases in food-production, the revolutionary arts brought these potentialities to realization. The new arts supplied the beliefs and the subjective cultural power required to carry out the urban revolution. Where man was without these, there were no urban revolutions. There was agriculture, there were people, there were fertile lands and even teeming river valleys in many parts of the world; these objective factors were present in many preliterate communities that did not urbanize. Daniel mentions the valleys of the Ganges, the Irrawaddy, the Mekong, the Congo, and the Amazon as apparently favorable sites for urbanization which did not produce early cities.

The ceremonial-monumental arts of the urban revolution were, as mentioned before, farseeing and long lasting. Long-range projections of thought and deeds are not rustic traits. The small farmer cannot be richly imaginative or very ambitious. He or—perhaps more probably in the early Neolithic—she was lifted only as high as her corn and bean hills raised her. She was allowed by her circumstances to see into space no more than the length of her seed furrows and in time no further than through the next winter. She prospered within these limits, however. And as she prospered, contradictions developed within her prosperity to move her— or, perhaps, to move her mate—in the late Neolithic toward urbanism and its revolutionary mutation in spatial and temporal perspectives and in social organization.

To repeat, the urban revolution was an esthetic, not a logical transformation of the means of production. The long-continuing conservatism of the world's villages shows that what was to draw some of them into cities was not something as objectively compelling as the post-Paleolithic

climate changes which had inexorably pushed along the food-producing revolution. Cynoecism had no such meteorological force at its back. It was brought about by the subjective persuasions of the arts, rather than the objective threats of famine and drought.

To assert that the subjective agencies of the arts were decisive in the urban revolution is not to deny the existence and power of objective factors that also prompted the change. The plow drawn by domesticated animals, enlarged garden plots, surplus food, and growing numbers of people with relative crowding were objective developments that must have created pressure for some alternations—if not for a drastic reorganization and enlargement of viewpoint—among late Neolithic villagers.

The objective existence of threatening neighbors would have stimulated the building of massive defensive walls. By the third millennium B.C., one of the earliest civilizations, that of the Sumerians, had a number of walled cities. One of these, Ur, was, according to Sir Leonard Woolley, surrounded by a steeply sloped rampart twenty-five feet high. Along the top of this rampart, King Ur-Nammu of the Third Dynasty (about 2000 B.C.) built another "great wall of defense 'like a mountain.'" Woolley also says this rampart was no less than seventy-seven feet thick at its base. The Indus Valley cities of similar antiquity, at Harappa and Mohenjo-Daro, had "impressive citadels with revetments and strong defensive walls" which "rose upon an artificial platform thirty feet high," Stuart Piggott tells us. They fell before invading Aryans about 1500 B.C.

City-building was not primarily defensive. Around ceremonial arts, it was creative and expansive. The threat of attack stimulated large-scale building and organization in some, but not all, agricultural areas. Monumentalism appeared in art apart from military wall-building necessity. The Mayans had ceremonial centers with gigantic monuments. They fought wars, but had no great fortifications. Among the pyramid-building Aztecs, according to archeologist G. C. Vaillant, "formal fortifications were rare," and "the hieroglyph for capturing a town" showed the burning of its main strong point, "the ceremonial center itself."

Massive walls built as defenses against nomads and urban rivals went well with the gargantuan scale of art and construction fancied by citifying revolutionaries. But the megaliths found in many parts of the world substantiate the thought that bigness was attractive for reasons entirely apart from defense. And real and long-continued threats from nomads as well as from settled neighbors caused comparatively few villages to amalgamate into cities and to build gigantic walls. City-building was motivated successfully only where the revolutionary arts of monumental ceremonialism were present.

The wealth that attracted nomadic herders and food-gatherers had made the cities practicable. But to have cities, the surpluses had to be

made socially available. This meant that the individual farm worker had to be deprived of the crop he had tended: something which cannot have been easier to do in the past than it is in the present. To lay the ideological and emotional basis for this expropriation, the arts were called on. Then came conscription and enslavement of citizens by fellow citizens and the farm produce went into the warehouses of the art-created temples. The gods of the ceremonial centers, in the persons of the king-priests, soon gained complete control of the land and its fruits. The clerks of late Sumeria, according to V. Gordon Childe, "pretended that kingship had descended from the heavens thousands of years before the mythical Deluge, Noah's flood of Hebrew tradition." For "clerks" we may read myth-making artists. From early days in Sumeria, Woolley says, "the entire territory was the property of the city's patron god." And in Egypt as well as in late Mesopotamia, "the government, vested in the person of the ruler, was in theory entitled to the whole produce of the fields." In Egypt, also, the people as well as what they produced "were equally the property of their divine ruler."

The archeologists' digging has shown how this expropriation evolved. Long before any city had appeared, there was a shift in habitual art practices among the early farmers, a shift that pointed toward monumentalism. Hunters decorated their holy places, but of course they did not build, or even dig, the caves which became their shrines. These were appropriately hunted out, found, or "gathered." Primitive farmers did not at first build ceremonial centers, either. "Usually the Neolithic folk kept their cult objects in their own huts," Jacquetta Hawkes tells us. But when "special buildings might be communally instituted as places of worship" as in Jericho and the proto-Sumerian al'Ubaid villages, "the communities are beginning to lose their simple rural character and develop toward little towns." At the Mesopotamian site of Tepe Gowra, the ancient remains of three successive shrines were found. One was 40 by 28 feet, another 57 by 43 feet.

When the votive figures were moved from the corner of a hut to specially built structures, that is, to the ceremonial centers, the proto-scientific agricultural revolution was giving way to the esthetic urban revolution. As the farm villages prospered, the arts, which had previously been brought out only at seasonal rites, went on permanent show. A time-honored reserve in display was abandoned and modesty in size soon gave way to its opposite, aggressive largeness. What was now required was art that could be seen from any part of the spreading village, rather than from a fireside in a hut. Monumentalism was called upon to astonish the beholders with its size which was proportionate to the wealth and power of the flourishing communities. "In the Mayan region," says Paul Westheim, "those in power, on whose orders the buildings were

erected, aspired not only to imposing effects; they wanted their buildings to give the impression of something unheard of, something that had never existed before." The collective-orientated new arts were designed to overawe the village individualists. These arts contradicted the intimacy of effect and the privacy of response evoked by domestic idols.

The first takeovers of villages by esthetic ceremonialism and the rise of the new social organization centered on monumental arts have been uncovered in numerous excavations in Mesopotamia. These show us occupation sites in series leading back to the previously mentioned al'Ubaid culture. Well before 3000 B.C., these people passed from Neolithic agrarianism to the new social organization. Woolley tells us of excavations that "brought to light the superimposed ruins of no less than sixteen temples all belonging to the al'Ubaid period." The rubbish and ruins of succeeding cultures nearby formed heaps sixty feet high. Even the wreckage of these past cultures, it would seem, is monumental.

At the top of one such heap at Uruk, according to Childe, "one is no longer standing in a village green but in the square of a cathedral city. In the foreground lie the ruins of a gigantic temple measuring over all 245 feet by 100 feet. . . . Behind it . . . rises an artificial mountain or ziggurat 35 feet high. . . . On it stands a miniature temple measuring over all 73 feet by 57 feet." The remains of a column almost eight feet in diameter were found at Erech. For a temple at Ur built about 2100 B.C., a whole section of a city was set apart, according to Woolley. This section was 810 feet by 660 feet with a "ziggurat set in a higher terrace surrounded by a double wall of defense and entered through a monumental gateway." The pyramid of Egyptian Khufu, built about 2900 B.C., was 755 feet on a side and 481 feet high. It was built with 2,300,000 blocks of stone, averaging 2.5 tons in weight, while the slabs that formed the roof of the king's chamber, Woolley says, weigh nearly 50 tons apiece. Contemporaries of Ramses, visitors to an Egyptian ceremonial center about 1300 B.C., might have seen "stelae and obelisks made of blocks of stone of unprecedented size, dressed and polished. All along the narrow, basalt-paved alleys, crouching lions kept watch in front of the gates. Before the pylons were line upon line of colossal figures, both standing and seated. Palaces and other buildings extended along either side of an avenue of sphinxes," according to a reconstruction by archeologist Pierre Montet.

A kind of concave monumentalism occurred in early Asia. At Mohenjo-Daro, described by Piggott, there was a great bath or "tank" nearly 40 by 24 feet and 8 feet deep. Steps led down into it from each end; it had a drainage system and it was surrounded by a cloister. "The Great Bath takes its place well in a sacred site when one considers the 'tank' ancillary to every Hindu temple of the Middle Ages." To keep this tank filled

with fresh water, situated as it was on the raised ceremonial platform of the citadel, must have been a monumental task for the water carriers since its capacity was nearly 8000 cubic feet. Walter Fairservis describes what seem to be everted pyramids in early China. A large number of tombs from the ancient Shang Dynasty have been discovered at An Yang. Typical was a sunken grave, 47 by 39.5 feet, stepped down to 15 feet deep. In its center was another pit, 15 feet deep, and in this yet another, 8 feet deep, for the body.

In his study of the Aztecs, G. C. Vaillant compares the ceremonial centers in Middle America to the great cathedrals of the Middle Ages. According to other authors, the temples of the Incas at Machu Piccu had walls more than 12 feet thick, and a fort at Sacsahuaman took the labor of 30,000 men in its building. Other statistics on monumentalism in Mexican America show ancient sculptures of up to thirty tons found in La Venta, in the state of Vera Cruz; at Monte Alban in Oaxaca were stone columns 6.5 feet in diameter, ceremonial stairways 131 feet wide; Hibben says "the Cholula pyramid is the largest artificial structure in the world," measuring 1070 feet on each side, the whole covering 60 acres; the Toltec truncated Pyramid of the Sun at Teotihuacan is 700 feet wide at its base and is over 200 feet high.

There are literally miles of sculptured temple walls surviving from the monumental past in Cambodia. At Angkor Thom, among the ruins of temples and royal palaces are rows of huge seated stone figures.* A seventh- or eighth-century figure of a reclining Buddha, thirty-seven feet long, was discovered recently in Soviet Tadjikistan. The height of a seated Buddha in Cave XX of the Yun-kang cliffs in China is forty-four feet. Another in the Lung Men group of caves in Honan Province is fifty-two feet, six inches in height.

Embryonic cities in many parts of the world repeatedly created cere-monial centers around huge art works. This sometimes occurred apart from, and often in advance of, actual city building. At this point in the transition from small food-producing units to large organizations, one of man's greatest social ambitions seems to have been to create works as large as the obtainable materials, surplus labor power, and technical skills permitted. The totem poles of the Northwest Coast Indians of America, carved from the trunks of giant redwoods, stood thirty to sixty feet tall. The monolithic figures of the Easter Island weighed from fifty tons and were thirty to forty feet in height. At Stonehenge, the central monolithic column, twenty-two feet high, was surrounded by a circle of columns almost as large. At Carnac in Brittany, there are long rows of such great standing stones. In sub-Saharan Africa, the people of Zim-

Columbia Viking Desk Encyclopedia, s.v. "Angkor Thom."

babwe, evidenced by its massive walls and ceremonial centers, were moving from the agrarian to the urban, esthetic-monumental revolution. So were the pre-Columbian people of the Mississippi and Ohio valleys in America. The Hopewell sites in Ohio have large and complex burial mounds and geometric earthworks enclosing anywhere from ten to hundreds of acres.

Changes in the arts herald—and help to create—social changes. The revival of animal representation in the arts of the monumental revolution had ideological and esthetic impact. It was a radical, subjectively oriented, rather than an objectively directed, change. While some animals were bred for food by the village agriculturists, grains had become the "staff of life." Growing grain became the principal occupation when food-gathering was displaced by food-producing. The urban revolutionists' revival of animal motifs in their arts was an overt contradiction of village mores and village relations of production. It grew out of the need for strong esthetic conditioners to replace the outmoded arts of the small cultivators. The new animalistic—and humanistic—art, reviving the emotive symbols of the food-gatherers, was employed in the struggles of the rising urbanists to take control from the farm villages.

Male human beings, seldom represented in the arts since the days of the hunter, began to figure prominently in the new arts. Animals, which had been the principal subject of the totemic arts but apparently taboo in most agrarian art, reappeared everywhere in the new urban arts. "The substratum of [Egyptian] art," according to Woolley, "was certainly a totemic system."

The relevance of totemism to the lives of hunter-gatherers is obvious. So is the connection between this way of life and the animal subject matter of its arts. The substitution of abstract and geometric designs for animal figures in the agrarian revolution was a radical change in art and in the social relations and values governed by the arts. Opposition to the tribal way of life was implemented by the village food-producers' use of inanimate decorative figures and by the rejection of animal representations. This gave expression to the natural antagonism of farmers toward any wild foragers, whether animal or human. Grain-eating birds and cattle, as well as reptiles, which had been sacred in totemic beliefs, could hardly have been idolized by harassed small planters. The reappearance of these animals in the arts of the monumental period expressed a clear challenge to the villagers' and small farmers' way of life.

In Sumeria and Babylonia, there were the bull, the lion, the goat, and other beasts; in Egypt, there were the hawk, the snake, the ibis, and the hippopotamus, as well as the lion; in Shang China, there were tigers, serpents, and elephants; in Peru, Guatemala, and Mexico, there were jaguars and snakes, among other animals, and the Mound Builders of

the Mississippi Valley made enormous earthen "effigy mounds" of bears, turtles, foxes. Art again came to the fore to organize and to regulate new and difficult relations of productions growing out of urbanization.

The content of the new arts could be expected to appeal to the male half of the settled village populations and to the still-surviving and reachable hunter-gatherers. Of course, the urban revolution could not itself have been the work of hunters or primitive food-grubbers. Conquests come from outside a community; revolutions can only come from within. They are made by the discontented. Discontent is a matter of values, and values are created through the arts. What is made acceptable by the arts at one time is made intolerable by the same means at another. The human male, the "Great Hunter" of the Paleolithic, was sharply reduced in status in the woman-operated small farming of the Neolithic. The new arts, recalling the prestige of the hunter and the excitement of the chase, were calculated to stir male discontent. The growth of the small gardens of the women into large plantations employing men at the plow, had prepared the way for this challenge to the women's high status. Now the arts presented the ennobled bull and the male lion and such hunters as the fabled Nimrod. The Shangs of the early Chinese dynasty were "great hunters and the chase was undoubtedly regarded as a noble and lucrative affair," Fairservis says. Although theirs was an agricultural economy, "one might almost think that this was a hunting culture," so important did the "sport of kings" seem. Fairservis notes the same passion for blood sports in "Egypt of the New Kingdom, Assyria, and Persia," and "the Rig Veda of Aryan India praises the godly qualities of the warrior hunter."

The revival—or renascence—of hunting-culture values had more important aims than flattering the men or attracting nomads into the labor forces of the changing villages. It served the vital needs of revolutionary reorganization within the expanding agrarian economies. In summoning up tribal precedents against the resistant agricultural and pastoral conservatives, the new arts would incidentally have appealed to the remaining hunter-gatherers, the "people of the wood," as the Mayas called them. But whether or not they drew in people from the more ancient human organizations, the animal-venerating cities soon absorbed the nearer villages and began to crowd one another, especially in the flood-renewed lands of the river valleys.

The monumental-ceremonial centers became the hubs of the earliest empires. History, which had just begun, began repeating itself like a cracked record. The social stabilization of the Paleolithic recurred as the stabilization of feudalism. There were struggles and other excitements in many places, it is true, during this feudal period. However, dynastic changes accomplished nothing, wars less than nothing. With the partial

exceptions of Greece and China, the world of feudalism remained
fundamentally unaltered through this long period.

In the ceremonial centers of feudalism, art was not merely edification
or entertainment. From the beginning of urbanization and of history,
until 500 years ago, everything moved through the impressive arts, visible
everywhere. In addition, leading persons everywhere in the urban revo-
lution became art figures. "The gods ruled the people, through the
priests, and the gods owned property as well," says William Howells. And
"thus were the temples in religious, political, and economic control."

The priests, then as later, were in fact dramatic artists. They acted out
the organizing and ruling dramas of their cultures. The kings were
stand-ins for the gods, or stunt men, and sometimes played at actually
being the gods. They recited their lines and made their gestures as the
scripts required. In Egypt, Amenhotep IV, as Akhenaten, tried to revise
the drama and make one male god supreme, as formerly the Great
Mother had been. The other priests-actors resisted him, reinstated their
own cues after his death, and restored their pantheon. Less noticeable,
perhaps, but no less important to the persuasive functioning of the
relations of production in the new societies were the poets, musicians,
makeup artists, designers of sacred vestments, and the artist-organizers
of the continuous pageant that life became in the vicinity of the cere-
monial centers. And there were the artist-builders who erected the mock
mountains and caves, the ziggurat ladders-to-heaven, and the everlasting
pyramids with their crypts. These were stage settings that make the
supercolossals of Hollywood seem moderate in size and trivial in con-
ception. The make-believe was made real; the man-made illusions carried
man out of rustic life into civil society.

Living through art, then as now, made life a charade and, then as now,
much more than a charade. The great monumental works survive in
Africa, Eurasia, Oceania, and America because they were designed to
last a long time. They are monuments of art and *to* art. They show man
to himself, to us, celebrating his efforts to use and surpass his illusions,
to lift himself by the bootstraps of his dreams, to believe the unlikely on
the way to achieving the improbable.

VIII
ART, TRADE,
AND INTELLIGENCE

Monumental ceremonialism, art- and agriculture-based feudalism, operated effectively, with just one major interruption, until it was brought to an end by modern capitalism. The interruption occurred in Greece in the seventh century B.C. As food-producing had disrupted tribal esthetics and had begun to produce a practical technology 7000 years earlier, so trade pursued objectively and for profit in seventh-century Greece disrupted feudal esthetics. Conditioning by the arts throughout most of his past had made man emotional, subjective, and nonrational. Trading for profit, an unsentimental, objective, and precise undertaking, produced logic and the phenomenon that we now self-consciously think of as "rational" intelligence. With the advent of independent trade in Greece, man began to "think" in a logical, objective way because the exigencies of individualistic buying and selling forced this development of the mind.

The result of the change in ways of thinking was that for a short time in early Greece the esthetic creature became a logical creature. This was a precisely apposite contradiction. It was a radical reversal of feudalism's total commitment to esthetics—a commitment that had made possible the organization of the great food-producing empires. The late V. Gordon Childe has noted two circumstances that helped bring about trade for profit in this period: Like the Phoenicians and Etruscans, the Greeks enjoyed the advantages of maritime transport in their pursuit of commerce, and, like the Jews, Romans, and Phrygians, they had the advantage of having emerged from barbarism directly into an Iron Age world already civilized—that is, citified—by monumental arts and feudal ceremonialism.

Because of their marginal situation in relation to the older Egyptian and Mesopotamian cultures, and because of their own recent barbarian heritage, the Greeks were free to absorb the technologies of esthetic-agricultural feudalism and its other rational endowments without having to accept its arts and beliefs. In other words, they could take the logical gains accumulated through the ages without having to pay the heavy esthetic inheritance taxes. They were the products of their own art tradition, which was verbal and poetic. They were not weighed down by

77

ziggurats or pyramids, palaces or temples. The generally docile people of the great feudal empires must have found from time to time that the bureaucratic systems of monumental ceremonialism were a heavy burden.

\ The ancestral Hellenes, whose pre-urban example of tribal democracy freed the later Greeks from ideological subservience to god-kings, had probably been food-producers at the barbarian level. They had come down to the Aegean Sea, perhaps as nomadic herders on raids, perhaps as migrants, perhaps as either or both at different times. There were widespread movements of pre-urban people late in the second millennium B.C., migrations in which semisettled slash-and-burn farmers as well as roving animal breeders turned for a while into far-ranging nomads. About the time of the Trojan War, land wanderers and piratical seafarers overran the borders of the empires and struck at the fortified cities. Egypt was attacked. The Hittite empire fell. Among these home seekers and pirates were, very likely, Hellenes, sacking, settling, or conquering as opportunity offered. The Hellenes certainly came from outside West Asian and North African civilization. They brought to mainland Greece, Crete, and Greece-in-Asia a prefeudal tradition on which they based some experiments in postfeudal capitalism.

In their immigrations or conquests, the Greeks took over some of the trading posts of the older civilizations. As operators of these, they were soon transformed into middle-class storekeepers and brokers, buying where goods were cheap and selling where goods were dear. They profited from shipping and marketing the raw materials of the hinterlands. They exploited the manufactured products of slaves and, after a while, of their poorer fellow Hellenes. They secularized economic power and began to secularize thought. As traders they needed to understand the learning and the technologies that urban feudalism had mastered, but they made an about-face from the worship of gigantic idols. They turned to another ideology, that of the rational mind, the projection of their own wits.

In this, the Greeks were not entirely alone. Among the organizational experiments of that time were those of other coastal peoples, especially in the nearby small Semitic states. Here, the esthetics of organization stimulated resistance to takeovers by the great empires and, when the resistance failed, struggles to regain independence. These organizational exertions involved renewals of the traditional values of mobile tribal and herding life, as against the fixities of existence in cities. The elected chiefs of tribal and herding groups and of the conquerors of Canaan and Troy could be compared favorably with the priest-kings who personified the urban feudal conglomerates. The memorized barbarian history or epic could be preferred to the colossal sculptured figure; the self-sufficient hunting, herding, or trading individualist could be admired more than the disciplined or servile collective man of the city-centered empires.

The protobourgeois trader was linked to the Stone Age hunter and the wandering herder, just as he formed a link to the later capitalist and, as we shall see, provided a precedent for the latter in his struggles against the authority of the feudal church. At first the Semitic antifeudalist might have been a herder, like sheepraising Patriarch Isaac. Then perhaps he became a temple-storehouse supervisor, like Isaac's son Joseph. From being an agent for a feudal power, it was a short step for an independent man to go out with grain and manufactured goods and trade for precious metals, other ores, and timber. In struggling Palestine, the small-state trader became an antifeudal moralist; in Greece, he was a businessman-philosopher such as Thales.

Regular trade was at least as old as metalworking and was necessary to it. Ores were rare in the Mesopotamian and Nile valleys and had to be bargained for wherever they were found. This meant continuous trading, but trading that was always under the thumb of a feudal priest. The common sense of secularized trade uncovered the rationality that must for a long time have been lying below the art-veiled surface of the urban mind. Objective intelligence outside of Greece, it would seem, was bemused by the bureaucratic ceremonialism that shaped feudal consciousness. Rationality awoke to contradict blind beliefs only after it was cross-fertilized with the barbarian skepticism of nonfeudal Greeks. Out of this awakening came the new intellect, the socially objective and grammatically precise trader intelligence that took over where the biologically and technologically objective producer intelligence of the agrarian revolution left off.

As a careful buyer, the trader-philosopher wanted to know of what the material world was made. Earth, water, air, fire, vapor, and atoms were suggested. Thales, the "father of Greek philosophy," was also a speculator in what today would be called olive oil futures. And as a "speculative" thinker, the trader would naturally be sharp, neither a fuzzy dreamer nor a wild gambler. Where earlier analogies for the mystery of creation were found in the mystery of birth, the trader turned to the familiar industrial processes of pottery-making and metalworking, as Benjamin Farrington points out. In those processes, the trader could trace finished products back to their crude elements.

The first specialization of abstract reason came out of this, the new and separate discipline of logic. It turned an emotional and subjective consciousness outward to definition and measurement and ultimately toward consciously practiced science. The hunter-gatherer's rationality had stopped at toolmaking. He was objective only in a limited way, and then only about the immediate ends of the food search. The improved intelligence of the food-producer arose from his efforts to obtain the rational goals of farming and herding. From these, the longer-ranging

perspectives of city-building and the foresighted production and storage of great surpluses went on to develop rationality further. But since the arts are subjectively oriented, the esthetic character of feudalism was bound to limit objectivity. The logical revolution of the Greeks contradicted this subjectivity.

With this radical logic went a revolutionary claim by the traders on production surpluses and an attempt to transfer power from hieratic actor-priest and feudal nobleman to bargaining merchant. As against emotional control, the trader intelligence asserted the rule of reason over agricultural, pastoral, manufactured, and human surpluses.

All these surpluses were eventually separated from other value relations and measured objectively in terms of the coinage that was invented for trading soon after 800 B.C. This new nonfeudal instrument, money, transferred power from collective ceremonial centers to individual pockets. Its secularized, nonesthetic, amoral economic force could operate outside any esthetic system.

The objectivity of trader intelligence assimilated its users, the forerunners of modern capitalists, to measuremental geography and logical geometry. Side by side with the bards' telling of the Cyclops and other monsters and wonders, Thales of Ionian Miletus was, says Farrington, teaching "by the doctrine of similar triangles [learned from the Egyptian land surveyors] . . . a method of determining the distance of ships at sea, and the art of navigation by the stars." And another native of Miletus, Anaximander, "made the first map of the world." In buying successfully, the traders must also have become the chemists, physicists, and general technological experts of their time. Trading made them shrewd judges of workmanship and, above all, weighers and measurers. It was from these skills that the traders became objectivists to a degree beyond anything the world had seen before. This canny and unemotional objectivity was turned not only on goods but on the trader's fellowmen as well.

Tribal man could be openly friendly or suspicious toward a stranger. The trader had to appear to be the one while being the other, a wily Ulysses compared to a more emotional and primitive Achilles. The caravan leader or ship's captain had to struggle against his own art-reinforced superstitions. In trading, he could not depend much—if at all—on charms, horoscopes, and auguries. And in buying one kind of goods, human beings, totemic identification of the self with all living things must have been chilled. Emotionalism here went down a great many degrees from the hot captures of tribal man and the vainglories of feudal battles, to the low point where money came to be weighed unfeelingly against men, women, and children.

The nomadic herder's animal breeding provided a partial precedent for the trader's heartlessness. For meat, the revolutionary animal breeder

coolly slaughtered his brother creature; for work, he as coolly gelded him. Where primitive man, the sympathetic brother of all animals, either killed or assimilated his human captive, the trader emasculated him culturally. The slave of commerce was first of all separated from his past. He was deprived of his cultural continuity and was not given the new social organization that his cultural consciousness required. To turn a human being into the marketable commodity of the slave trade requires that he be de-personalized, given the brainwashing that any prolonged isolation from esthetic stimulation inflicts on the social human being, the esthetic animal. It was such psychically castrated victims that Aristotle thought of as "natural slaves." (It is from this condition that the American blacks are now emerging. They are casting off the role of cultural eunuchs, nonesthetic, nonorganizational nonpeople.)

The antithesis of urban settlement to an impermanent camp, of a great granite monument to a bardic recitation, kept the nomadic part of humanity well outside of conventional feudalism. Yet eventually, as immigrants or conquerors, the nomads were absorbed by the monument-building peoples of Mesopotamia, Egypt, India, China, and Middle and South America. Although on the periphery of Middle Eastern feudalism, the early Greeks, because of their antithetical barbarian traditions, were not assimilated into the monumental culture of their neighbors. Since a part of their tradition was prefeudal, it followed that, in accordance with the nature of dialectical contradiction in which there is no neutrality, it also was antifeudal. The protobourgeois individualist, the Odyssean businessman, stood apart from and in contrast to the temple worker, the toiler in the god's vineyard. The profit-motivated trader rivaled the divine servant.

The definitive possibilities of words, perhaps following the example of precision provided by the bookkeeping trader's figures, became, in the work of some Greeks, instruments for realizing antifeudal logic. Writing done on tablets small enough to be portable changed the response to art from a shared group experience to solitary appreciation. The sound of a chant could be heard by all within earshot. A procession could be seen by everyone. The light reflected from a huge sculpture or a vast architectural structure reached all nearby eyes. But the light reflected from a clay tablet or a scroll could reach only the eyes of one reader. In that isolated reader's mind, bourgeois individualism began to glimmer faintly through the feudal and tribal mists. The individual read and interpreted—by himself. No magician-priest came between him and the text. He could do without clerical exegesis, ecclesiastical decoding; in Ionian Greece, he began to do so. The emphasis shifted from the collective under the god-king to the individual within the secularized group. At the Olympic games there were no team contests, perhaps

because, as C. M. Bowra says, "the Greek temperament was too hotly competitive for the cooperation required." In the time of Pericles, as in the Protestantism of later millennia, Everyman became his own hero and his own Vatican. He already had become his own accountant and, pondering by himself on what is and where it comes from, as a trader should, he became a materialist philosopher and a do-it-yourself theologian.

The roots of the revolutionary logic of Ionian Greece reached back to the first irrigation ditches and the first plowed furrows of the agricultural revolution. Ditch and furrow required the least labor if they were laid straight. For the figures-reading trader, the least means in money, labor, transportation, and geometry were equated. The straight line was the shortest and most economical connection between two points. When Thales used triangulation to determine the distances of ships at sea, he had to assume that the lines that formed his two-dimensional angles were straight lines, not curves or meanders. And then, three-dimensional reality was merely an extension of least-means straightness. Hence the cube was also definable and limitable as to volume, cost, and thought. For a while, everything in the trader's world must have seemed quantifiable, buy-and-sellable. The nondimensional, holistic primitive ways of viewing existence were put aside as fantasms. In Greece, and perhaps in China, urban man momentarily awakened from his art-created dreams.

The rational philosophies of early Greece were products of the contradictions within feudalism, contradictions that were to wait two thousand years more for full development. In the fourth century B.C., the Chinese developed similar philosophical speculations. In both countries, words, in logically formalized grammars, were used in attempts to disestablish the ideology of feudalism and to arrive at a secular truth. Although some of their ideas were remarkably alike, as Joseph Needham and others have observed, the geographical circumstances and cultural histories of the two countries were quite dissimilar. The Greeks came out of a barbarous hinterland to a fringe habitat. They occupied a margin of the great civilizations of Africa and western Asia. They became island and seacoast dwellers. On the other hand, the Chinese developed their culture in a continental setting, far from other early urban centers. It has been suggested that the Greeks' scorn of manual labor as degrading, or *banausic*, checked their development of technology and, by implication, of science and industrialization as well. But the Chinese did not have such prejudices. According to Needham, farming was secondary in honor only to scholarship, and there was "throughout Chinese history an appreciation of the dignity of manual work." Yet the farm-based mandarin bureaucracy of China was one of the strongest and longest-lived feudal

organizations in the world, surviving into the middle of the twentieth century.

Early Greece and China were not ready for the bourgeois revolution, regardless of their technology and science. Neither was prepared to use what we today see was the necessary alternative to the arts as a means of social organization and control—unremitting economic force. The best the Greeks could do was to generate a logic that was antithetical to religio-feudal belief.

The trader, in the person of the revolutionary Greek logician, tried to burn esthetics out of language so as to isolate and refine its rational elements, as the smelter fired the slag out of iron ore. Man, for the first time in recorded history, analyzed and specialized his speech, split it into its contradictory components. He tried to put aside the haze of poetry to get at definitive prose. The contradictions in speech between the emotional and the rational were not newly invented. They had been there, waiting throughout the ages to be uncovered, and the isolation from esthetics of these logical elements of language must have seemed an obvious thing to do, once it had been done. Although the tide of revolutionary logic was to recede presently, it had washed away many sandbars of superstition and it left many permanent marks of its own on the shores of man's consciousness, marks that the next tide of religious-esthetic reaction could not completely obliterate.

The myths and other arts of the earlier Hellenic past provided the traders with such useful antitheses as human figures to be presented in the arts as against the animals represented in feudal and primitive tribal art. "The gods of Homer are entirely anthropomorphic; the Minoan are largely animal," George Thomson observed. The myths of the post-tribal, pre-urban food-producers, out of whose ranks the ancestral Hellenes had come, had probably, in their turn, been specific contradictions of the animism and totemism of the preceding hunter-gatherers. The humanism of the Greek logical revolutionists, was antitotemic in part because, as mentioned before, feudalism had revived and used totemic animal figures in its own struggles against the first nonesthetic rationalism which had appeared in the food-producing revolution.

The new humanism pointed the way to later bourgeois individualism. Homer's tales prefigured this major antifeudal innovation. Bowra notes that "Homer never obtrudes. Everything that he has to say is said through the words and actions of his characters." In other words there was no feudal authority standing between art and audience. Each man was allowed to be his own interpreter.

The Greeks built their breakaway antifeudalism partly on trade and partly on the traditions of their barbarian past. Their prefeudal myths gave them individualistic male heroes and gods who were larger, but

only slightly larger, than life. From this background, traders emerged who were able to ask the technological and logical question, "What is the world made of?" instead of the religious-esthetic question, "Who made it?" Thales suggested that water was the stuff of which the world is made, Heraclitus said fire. Pythagoras, half logician, half esthete, led the way back to feudal religiosity by teaching that reality was created through the mystic power of numbers. So it was that, after a while, the humanism of Greek thought began to give way to the arts-created religions of a new feudalism. The choruses in the plays reinstated the artist-priest who told the audience what to think. Ceremonialism and ritual returned as the traders' independent city-states were absorbed by new empires. Feudalism still had the power to regenerate itself. (In its later Church-of-Rome form, it further downgraded the trader, outlawing mercantile capitalist finance, paying off usury with hellfire. In feudal China and India, according to Needham, the development of a merchant class and a money-centered economy was also sharply inhibited.)

In the renewed struggles between the antifeudal traders, merchants, oligarchs, or "tyrants," on the one hand, and the feudalistic landowners and aristocrats on the other, it was Greek art that decided the issue. The traders had at first been able to use the prefeudal traditions and the myths of the ancestral Hellenes against monumental ceremonialism, just as the later merchant-traders of the Renaissance and Reformation used the classical and Old Testament arts against the feudal Church. Since the Greek traders could not create a wage-working class, they could not make a bourgeois revolution, and Greek arts remained communal. Greek artists, Hellenizing monumental ceremonialism, created a cultural climate in which idealistic philosophers could contravene the logical materialism of the traders, and in which Socrates and his followers could prepare the way for the return of feudalism and its mystical beliefs.

The aspiration for intelligent objectivity, for formal, measured logic was suspended for two millennia. When the early trader class lost its bid for power, feudalism, with its monuments and ceremonies, its myths and fabulous histories, could again dominate the consciousness of mankind.

The primordial "intelligence" of esthetics, the wisdom of cultivated feelings, is a response to the arts, which were created to shape and arouse such a response. The subjectivity of the emotions is real enough, but the mysteriousness of consciousness and of desire and dream may be seen more clearly in the art works which evoked and molded them than in the unconditioned brain. Logical intelligence, the trader's verbal and definitive wisdom, took its being from his account books and from the weighing, measuring, and objective analyses of his merchandising practices. This intelligence has withered or flourished as the trader class has declined or prospered.

IX
ESTHETICS AND DIALECTICS

Business objectivity, which later produced the sciences, was verbalized early in the philosophies of the Greek commercial-dialectical materialists. As observed in chapter VIII, specialized logic, independent of religion and the arts, began with those materialists. But this logic almost immediately faced baffling paradoxes and verbal ambiguities that demonstrated the essential interdependence of logic and esthetics. Contradictions recur as rational dilemmas throughout the history of thought. These anomalies in formal logic can be turned into expositions of esthetics.

A few examples are found in:

1. Zeno's proofs of the impossibility of motion.
2. The idealism of Plato.
3. The dualism of Descartes.
4. The nonformal in Hegel's dialectics.
5. Georg Cantor's mathematical infinities.
6. Heisenberg's indeterminacy principle.
7. The "Big Bang," modern astronomy's exploding universe.

There are many other such puzzles which invite esthetic criticism and an art-based reinterpretation. They disturb scientific and logical minds but they are understood and dealt with continuously in the arts.

1. Using the verbal logic of his time, Zeno, of the ancient Greek colony at Elea, argued that motion was impossible. An arrow shot into the air must at all times be in some place. But to move, it also must be between places. Logically, this "between places" is nowhere and, therefore, Zeno concluded, motion is logically impossible. In "The Dichotomy," Zeno postulated that to traverse a given space, first half the distance must be covered, then half of what remained, and so on. The traveler would go one-half, three-quarters, seven-eighths, fifteen-sixteenths, thirty-one thirty-seconds of the way to his destination, but would never arrive.

Zeno makes sense in esthetics, which does not accept that his "given" or implicitly limited space is all the space there is. Esthetics sees the world as undefinable, forever moving. Zeno makes problems in definitive logic which starts with the assumption, often unstated, that the world is measurable and, therefore unchanging and static. The interdependence of esthetics and logic calls for the criticism of each by the other as

necessary to their correlation. Neither matter nor motion exists independently in reality; neither logic nor esthetics is self-sufficient even in rational or emotional abstractions.

For example, science tends always to seek measurable, countable units. All the way from Democritus and his indivisible atoms in the fifth century B.C. to the modern physicists' quest for the ultimate bits of the atomic nucleus, the rationalist's search has continued. Art, in contrast—and in necessary contradiction—is not concerned with measurable and countable units. There are no esthetically meaningful bits or particles. The isolated word of a poem has little more artistic significance than the letters out of which it is spelled. The strokes of a brush in a painting, the bumps and hollows of a sculpture are nothing by themselves. And yet all works of art are built up of these nothings. Like Zeno's paradoxical arrow, the elements of every art work are forever between places. They are abstractions of the motion that Zeno is supposed to have denied. And Zeno as a logician with his arrow has "proved" the esthetic proposition that what is nondefinable is as real as what is measurable and definable.

We get the same results when we check Zeno's "Dichotomy" by requiring him to retrace his steps. This involves the legitimate mathematical process called commutation. In other words, we send him backward by the same method he used to go forward: He goes one-half the way back, three-quarters the way, seven-eighths the way, and so on. It is obvious that he can no more get back to his starting place, if he was ever there, than he can get anywhere else by his fractioning. And if we repeatedly reverse Zeno by commutation, we will have him bounding back and forth like a Yo-yo on an infinitesimally shrinking string. Rather than proof that men (or arrows) occupy static and definable spaces, Zeno's paradoxes show that things are forever moving, a dialectical discovery that his Ionian predecessor Heraclitus had already made. Neither Zeno nor Heraclitus has come down to us as a theorist in esthetics. They did not recognize the arts as man's way of apprehending the nondefinable aspects of existence. Nevertheless, their arguments make this implication. They illustrate the interpenetration of opposites, showing that when logic is extended to its limits, it turns into, or synthesizes with, its opposite, esthetics. And they foretell the ultimate synthesis of reason and emotion in man's social life.

The calculus deals mathematically and, in practical application, successfully with "change and rates of change." But it assumes that things in motion occupy a series of static positions that are, therefore, mathematically definable. This assumption seems either to ignore Zeno or to agree tacitly with his logic. Kasner and Newman said, "The calculus has the same static properties as the multiplication table and the geometry

of Euclid. The calculus is but another interpretation, although it must be admitted an ingenious one, of this unmoving world."

2. Plato considered the arts as merely imitative and hence three steps removed from reality, which he saw as first, idea; second, thing; third the reflection of thing. Plato was aware of the power of the arts and mistrusted it; he was unaware that his idealism was based on illusions of being and illusionary ideas of things that the arts had helped to create. He did not recognize that cultivated consciousness—and with it, imagination, values, and concepts—came out of the practice of the arts. The illusion-creating arts preceded ideas; therefore, ideas of things could not have existed before and apart from either arts or things. A drawing presents the eye and the brain with an image. It may look like a cow, but it is not a cow. It seems to be something other than itself, just as a shadow, outlined and separated from the object that cast it, can abstract and represent the object. Carrying this process further, a triangle or a circle can abstract the appearance of a class of objects. The illusions of the arts have made dualism possible. It was art that first separated things and ideas, and it is art that can reunite them.

Plato did not recognize the role of the arts in the development of the mind and so the mind seemed to him an anatomical fixture, with its ideas inborn. If this were true, the sources of thought and the evolutionary and materialistic sequence from objective to subjective and from things to ideas could not be traced. This is even more obviously true in regard to the origin of the values—beauty, goodness, justice, temperance, courage—that Plato assumed also to be at the basis of true reality. When the arts in a society have produced such values, then these values exist. Other values and other ideas have been produced by other arts all the way back to the beginning of man's cultural consciousness.

3. Descartes, the founder of analytical geometry, separated the mental and the spiritual from the physical. It is easy to understand how a mathematician could believe that truth could be grasped directly and intuitively by reason. Descartes's dualism, no less than Plato's, came out of unrecognized esthetics. The mathematician's flashes of insight, like those of other workers in both the sciences and the arts, cannot be accounted for in a dreamless, matter-of-fact universe. The mind itself is inexplicable unless it is given a base in culture and the arts.

The nonesthetic quest for truth has led thought far afield. Descartes resorted to "doubt" as a way to avoid preconceptions. He said that doubt alone could not be doubted. To him, this activity of the mind proved existence: "I think [by doubting], therefore I am." But doubting is neither easy nor natural for art-conditioned man. It takes a conscious effort—and counterconditioning—for man to doubt whatever he has been conditioned to believe. It was not doubt but art-generated belief that

built up man's consciousness. To escape from outmoded beliefs and from superstitions and religions, it is not necessary to challenge one's senses; it is necessary to create new arts out of which will come new beliefs and values.

"I feel, therefore I am," is a more basic axiom than Descartes's. Primitive sensation preceded thought by many eons. Since feeling extends beyond man through all life, it offers a sounder foundation for being than Descartes's somewhat anthropomorphic idea. The refined feelings and cogitations of man were not inborn. They had to be cultivated through ages of primordial, tribal, agrarian-herding, and urban arts to produce the belatedly skeptical thinker. Man had to suspend many of his art-generated beliefs as he progressed step by step toward conscious rationality.

4. Dialectics, which literally means discourse between differing views, also signifies process in general. It is the continuous transformation, the dynamic interconnectedness of things. For sensitive organisms, dialectics is awareness of both matter and energy. If the arts are man's means of apprehending and conveying the dynamic, the continuous, and the moving, then art theory concerns itself with man's ways of abstracting process and change. Esthetics becomes that through which man understands and works with the nondefinable aspects of existence. And in this, esthetics becomes synonymous with dialectics.

5. The nineteenth-century mathematician Georg Cantor developed proofs that the numbers with which we note our measurements are not themselves measurable. He showed that, paradoxically, in this mathematical infinity of numbers, wholes may be no greater than some of their parts. For example, all the even numbers, taken as a class, are equal to all the odd and even numbers taken as another class.

Curiously, this is sometimes put forward as a logical example of defining the continuous. Bertrand Russell is quoted by Sir William Dampier as saying, "Ever since Zeno, philosophers of an idealistic cast have sought to throw discredit on mathematics by manufacturing contradictions which are designed to show that mathematics has not arrived at real metaphysical truth. . . . Georg Cantor invented a theory of continuity and a theory of infinity which did away with all the old paradoxes upon which philosophers had battened." Dampier himself adds, "The problem of continuity is essentially the same as that of infinity, for a continuous series may have an infinite number of terms. . . . [Cantor] showed that beyond all the numbers that can be reached by counting are the infinite numbers of mathematics."

Russell is not accurate in saying that philosophers had "manufactured" the contradictions that arise out of the limitations of definitive logic itself. Dampier's phrase "continuous series" shows where the paradoxes come

from. It is a clear contradiction in terms, for what is continuous must be opposite in character to what is serial; the continuous cannot be a succession of discrete things, terms, or concepts.

The great nineteenth-century physicist Clerk Maxwell described motion as a "change of position going on continuously in space and time."* This is a scientific stutter, a way of describing motion as a continuity. Anything "going on" is continuously going. To interrupt the going, the motion, is to abolish the continuity. Change can exist only as it exists continuously, for the absence of change is the absence of its continuous character of always being different. The absence of this continuousness at any instant abolishes the existence of change at that instant. This is what Zeno saw.

6. The twentieth-century physicist Werner Heisenberg stated the principle of indeterminacy. He and others found that it is not possible to determine simultaneously the velocity and the position of an electron. Aside from the high velocities and the fineness of the subatomic particles or waves concerned, it would seem that the principle of indeterminacy is fundamentally a restatement of the contradiction of motion and position, which is just as baffling with larger and slower objects such as arrows.

7. It is not the Little Red Hen who says "the universe is exploding." It is our astronomical physicists. Their alarming conclusions rest on the "red shift" in the light reaching us from the most distant galaxies. The galaxies seem to be receding from us in all directions at speeds that cause this measurable color displacement. These observations have led to the hypothesis of an exploding universe. Apparent velocities observed in the recessions of distant galaxies have reached to more than three-quarters of the speed of light. It has also been observed that these velocities increase regularly with the increasing distances of the sources of light. Does this regular increase of speed extend with increasing distance? Do more distant radiating bodies go faster until these sources of light approach the velocity of light in receding from us?

Formal, definitive logic must find, or invent, beginnings and ends in order to make the defining measurements on which it is based. The end required by formal logic is at hand in the "exploding universe." The spectroscope shows us the red shift, a ubiquitous galactic "Doppler effect." Matter is apparently scattering so widely that "entropy" must surely prevail. The "increase of entropy" is the lifeless, energyless fate predicted for any closed system by the Second Law of Thermodynamics, another expression of measuremental logic. Entropy, increasing to a maximum, as when atoms or galaxies are so widely separated that there can be no interchange of energy, will predictably leave the universe lifeless, unable to work. Scien-

*Encyclopaedia Britannica, 9th ed., s.v. "Physical Sciences."

tific logicians, calculating backward from this end, from these galaxies which are not only receding but receding in all directions away from us, also arrive at a suitably static *beginning*. This other limit of the universe is imagined as a "superatom" in which, countable billions of years ago, all matter was concentrated.

Closed systems may exist nowhere but in the minds of defining logicians. The probabilities are at least even that the universe is not closed, but open and infinite. Esthetics, criticizing static logic, tells us there is an aspect of reality which is not measurable. It can ask why cosmic and subatomic calculations use the process of squaring which mathematical logic has employed from Pythagoras' triangle to Einstein's $E = MC^2$? Is reality actually square rather than round, or is it merely treated as square to prefit it to static, measurable logic? Einstein thought space curves, but the square in his equation treats space as straight. Perhaps using the circular power of *pi* to make his formula read $E = MC^{3.14159\cdots}$ might better represent a limitless, moving esthetic universe. Esthetic criticism may also note that the motions of the apparently exploding universe have brought us around again to the geocentric view of the cosmos. If the recession of galaxies go on in all directions away from us, are we on earth again centrally placed? Are we alone motionless, like the boy on the burning deck whence all but he had fled?

Radiological evidence gathered in the last few years has made it necessary for astronomers and cosmologists to ponder over "objects moving faster than light . . . whose energy output defies explanation" (New York Times, January 27, 1972). They speculate on "black holes" through which matter and energy escape to universes other than the one we know, and "white holes" through which alien matter, obeying alien laws of physics, intrudes into our cosmos. And when we try to follow physicists into the subatomic world of quarks, hadrons, and muons, we go from logical measurementality into limitless, esthetic fantasies that might well have come from the other side of Alice's looking glass. In 1974, when he and his colleagues were "being forced to consider crackpot ideas!" the president of the American Physical Association said that "there is something terribly wrong" (New York Times, April 29, 1974). The world of science fades into the world of art; objective fact unites with fantasies and dreams.

X
ART AND PHILOSOPHY

A perfect philosophy—or even a generally workable one—should bring together the arts, through which we have created our minds and consciousness, and the sciences, through which we have become objectively powerful. We have not yet succeeded in unifying our inner and outer selves. We have been artists or scientists when we need to be both together. From the beginning of history, we find that either logic or esthetics has been suppressed in almost any given society. A historical inspection of the results of the alternations in dominance from esthetics to logic and back to esthetics, from emotion to reason and back to emotion, becomes necessary to our understanding of philosophy's failure to unify these two aspects of culture.

Ancient China and Europe of the Middle Ages are witnesses that art was the essential element in the feudal form of social organization. The feudal bureaucracy of old China existed in a setting of glorious art. Every detail of life, including tea drinking, had been ceremonialized. Science and technology made considerable progress there until feudalism, consolidating its powers, repressed the radical traders. Joseph Needham tells us that "the merchant interests, of such cardinal importance for the rise of modern science, was systematically suppressed in China."

Spain, when Muhammadan, had already seen the crushing of antifeudal tendencies. Following this, the Moors and eventually the whole Arab world went into a decline, in the opinion of science historian George Sarton: "Two Arab writers, the Muslim Ibn Rushd and the Jew Maimonides . . . shared with St. Thomas Aquinas the distinction of being the greatest philosophers of medieval times." The first, also known as Averroes, was a student of Greek philosophy who tried to reconcile religion with the logic of philosophy. He was rejected and held in disgrace by his fellow Muslims. "Arabic science and Islamic progress were killed by religious intolerance and obscurantism. There is no other example of a great culture being stopped dead by theological conceit and stupidity," says Sarton.* J. D. Bernal agrees: "This was probably a major reason for science withering away in the later centuries of Islam, which

*Quoted in J. D. Bernal, *Science in History* (London: C. A. Watts, 1957).

became culturally and intellectually static.". In Islam, in other words, the arts overcame the sciences; esthetics won out against logic.

In the Crusades, Islam's opponent, the Christendom of Europe, took up logic just as the Arabs were abandoning it. The philosophy, mathematics, and science of classical times arrived first in the Italian and Iberian peninsulas, where Christian feudalism was shaken—though it did not fall—by a prospering trader class. The new old learning then moved on to France, the Lowlands, England, Germany, and the rest of northwest Europe, carried by translations from the Arabic in which it had been preserved.

The changeover from feudal esthetics to nonesthetic, objective logic was drastic. Galileo ruled the subjective and qualitative out of science: "That a body must be white or red, bitter or sweet, sounding or mute, of a pleasant or unpleasant odor, I do not perceive my mind forced to acknowledge. . . . I think that these tastes, odors, colors, etc., on the side of the object in which they seem to exist are nothing else but mere names, but hold their residence solely in the sensitive body." Perhaps this thought was among those that came to Italy through the Arabic from ancient Greece. In the fourth century B.C., the atomic theorist Democritus had said, "According to convention there is a sweet and a bitter, a hot and a cold, and according to convention there is color. In truth there are but atoms and a void." "Bodies are perceived as with qualities which in reality do not belong to them, qualities which in fact are purely the offspring of the mind," said Alfred North Whitehead, discussing seventeenth-century scientific theory. "Nature is a dull affair, soundless, scentless, colorless; merely the hurrying of material, endlessly, meaninglessly. However you disguise it, this is the practical outcome of the characteristic scientific philosophy which closed the seventeenth century. . . . It has held its own as the guiding principle of scientific studies ever since. It is still reigning. Every university in the world organizes itself in accordance with it." The denial of the qualitative by objective science repeats Zeno's denial of motion in the name of definitive logic. Evaluations, qualitative judgments, emotional preferences are created for man by the arts. Motion and emotion are objective and subjective aspects of the same thing in the esthetic view of reality, a view opposed by the thinkers for new and old traders because it acknowledges the existence of the subjective and the nonrational.

Behind the Renaissance facade of revived classical arts, the merchant interests spread throughout western Europe. They developed their urban bases of power and their antifeudal politics. Esthetics declined in these years of change as logic rose. "The few friendly moves on the part of the philosophers toward art are the exceptions rather than the rule in the seventeenth century. For the most part the arts found themselves in a

cool, unpropitious philosophical milieu. Those who should have been their philosophical interpreters were absorbed in the progress of science. If, then, art was to walk with the times in this scientific and progressive age, it had to shift for itself. Philosophy gave it little direct help," say Gilbert and Kuhn.

The bourgeois philosophers of the seventeenth and eighteenth centuries, first of all in England, were required by the mercantilist commitments of their time to minimize the mass arts. The revolutionary traders needed workers and found it necessary to replace the persuasion of the arts with the coercive force of money. Under economic pressure, land-bound, church-dominated peasants were uprooted and transplanted to be wage-workers for traders.

Natural philosophy, as science was then called, had not yet been applied in the transformation of the means of production. The industrial revolution was still in the future. Trade and manufacturing under the control of traders had increased, but production remained basically agricultural. Bourgeois man had no radically new mastery of the objective environment. Navigation had improved slightly and European ships sailed around the world. However, the commercially minded Phoenicians, Minoans, Greeks, and Carthaginians had sailed widely hundreds and thousands of years before. And the hunting-fishing and food-gathering Polynesians had sailed over much of the Pacific before the European traders "discovered" it.

For the bourgeoisie, the new scientific theories were intellectually stimulating, but their utility, until the industrial revolution, was political rather than technological. Science put the arts—and feudalism—out of countenance. But those who read the past from the viewpoint of the triumphant scientific present grant the Copernican and Newtonian revolutions a status that they did not enjoy in their own times. Swift's practical, middle-class voyager, Gulliver, gives us a satiric—but socially realistic—view of the sciences of his day. In his report on the Academy of Laputa, he tells of projects to extract sunbeams from cucumbers, and for softening marble to use as pillows and pin cushions.

Nevertheless, the new sciences, astronomy in particular, put both the weak, empirical logic and the strong esthetics of the Church on the defensive. J. D. Bernal says that Giordano Bruno "made people think and argue about the Copernican theory. For all the Catholics that his execution frightened, as many Protestants must have been encouraged." Early capitalist science served—perhaps mainly—as a source for the antifeudal polemics of bourgeois philosophy and as a cover for bourgeois anesthetics. While the attention given to the sciences by philosophers increased throughout the seventeenth century, that given to the arts declined from the little granted it by Francis Bacon in the early years to

even less given it by John Locke toward the end of the century. And yet the monumental arts of the Middle Ages still loomed on every horizon, and the Tudor Renaissance was a living memory. Gilbert and Kuhn observe: "The typical philosophical superciliousness toward the products of the imagination broke down at points, and in places where one might little expect it, as in the appreciation of poetry and fancy by Hobbes, a thoroughgoing materialist." Hobbes, like Bacon, was a grown man when Shakespeare died. The arts of the past were still powerful enough presences in England to explain why Hobbes was willing to grant theoretical and practical importance to esthetics.

But while seeing the mind dialectically as matter in motion, Hobbes turned to mechanics to explain man's individual and social life. In his thought, the mainspring of the clock replaced the art-created soul. Introducing his Leviathan, he wrote, "May we not say, that all *Automata* (engines that move themselves by springs and wheels as doth a watch) have an artificial life? For what is the heart but a spring and the nerves but so many strings, and the joints but so many wheels, giving motion to the whole body?" And he goes on to expand his watchwork man into a society: "A *Commonwealth* or *State*, in Latin *Civitas*, which is but an artificial man," that is, machine.*

A watch may go by itself, but someone must set and wind it. Late seventeenth-century empiricist John Locke felt that whatever god did the winding, each human clock set itself. He argued that an individual's experiences took place in his isolated head, that the mind was a recorder of what was impressed on it from outside. Sensations went in and arranged themselves according to the sequence in which they occurred. The variations of sensations in the mind could, in some unspecified way, produce consciousness, ideas, morality, recognition of natural law, and the rest of culture. Locke's eighteenth-century successor, the skeptical David Hume, concluded that, on these premises, there could be no reliable knowledge of an external world or of mind itself; to be consistent, science should merely describe the sequences of human perception according to the principles of individualistic associationism.

A head filled with newly made clockworks would not contain old superstitions. More than that, such mechanical ideas allowed no place for dreams or emotions. When the Royal Society, as Bernal says, "made science into an institution," its first pronouncements were nonesthetic, if not antiesthetic, in tone. The Society called for the removal of "luxury and redundance of speech," rejecting all "amplifications, digressions, and swellings of style." It favored plain writing "without vicious abundance of

*Quoted in Edwin L. Burtt, ed., *The English Philosophers from Bacon to Mill* (New York: Modern Library, Inc. 1939).

phrase" or "stricken metaphors" and a "close, natural, naked way of speaking." V. S. Pritchett tells how "a Fellow of the Royal Society who had once referred—before he was made a fellow—to the 'ethereal coal,' altered it to plain 'sun,' and 'earth' took the place of 'this inferior clod.'" Locke in his *Essay Concerning the Human Understanding* said that colorful speech might do for pleasure-seekers, "but yet," he insisted, "if we would speak of things as they are, we must allow that all the arts of rhetoric, besides order and clearness, all the artificial and figurative applications or words eloquence hath invented, are for nothing else but to insinuate wrong ideas, move the passions, and thereby mislead the judgment, and so indeed are perfect cheats." One of the main things excluded from "things as they are" by these bourgeois thinkers was esthetics. Their hostility to feudalism led them to this exclusion, just as their objectivity and their definitive logic led them to a mechanical model of the mind.

Besides disparaging the arts, the new thought was important to the merchants on other counts. First, it won respectable secular standing for the merchants' cool rationality. Lending at interest and making large profits, which had been forbidden as sinful in the Middle Ages, now was encouraged and admired. Second, individualism was a justification for the social, economic, and spiritual atomism of capitalism. The separation of each person from all others gave the money man, as a supposedly weak and isolated individual, the right to deal with each of his moneyless fellows as another isolated individual. The common man, like the slave before him, was taken out of culture and art, out of any group, and out of bourgeois history. The generations of unlimited exploitation of "free" labor were opened, as Karl Marx pointed out.

Thus, bourgeois philosophy rationalized the merchants' nonesthetic social practices. The West European traders had demonstrated how, without either arts or chattel slavery, they could control people through money power. With their exclusion of the "perfect cheats" of the arts, bourgeois thinkers could replace esthetically conditioned man with an artless, and therefore unorganized and easily exploitable, man. This man owned nothing and had claims on nothing. He was isolated from his contemporaries and cut loose from his past.

Bourgeois philosophy dissected living thought to excuse the merchants' social surgery. According to Professor Edwin L. Burtt, Locke made "the starting point of any scientific investigation not a general truth of reason but a particular psychological event." He produced a model of a man who could know only what happened to himself. To such a philosophy, historical and current arts and art-derived values were as irrelevant as were the experiences and needs of the poor. Individualistic isolation and discontinuity were completed by Hume. For him, says Professor Burtt, "if

we propose to be consistent, all we could possibly know is the cluster of our present perceptions."

Feudalism held on in Italy, France, and Spain, where, in the sixteenth century, Juan Huarte spoke for poetry against logic and science, saying that Democritus in his old age arrived at so great a perfection of rational understanding that "he utterly lost his imagination."* The interest in esthetics in these feudal countries may be contrasted with the bourgeois preoccupation with logic. The climate of philosophy where feudalism survived was not so "cool and unpropitious" toward esthetics, as it became in mercantilist England. In Italy Giambattista Vico asserted that the primeval power of the imagination owed nothing to logic. He said that ancient beliefs lacking abstract ideas and rational criticism came out of poetry.† He made the "poetical function coequal with that of the intellect." He credited Homer, as artist, with founding Greek civilization and inspiring its philosophers. In France (as mentioned in chapter IV), Condillac speculated that cultural communication began with the dance.

Abbé Dubos, a functionary of the feudal church, tried to restore the arts to a major place in philosophy. In a work published in Paris in 1719, he referred back to Aristotle and identified the arts with motion. This granted to esthetics a primary relation to objective nature, a relation, as we have seen, that bourgeois theorists did not concede. Dubos held that one of man's primary needs is for the subjective motions of feeling; man must exert himself against ennui, the threatened absence of feeling man knows in boredom. Dubos asserted that our arts minister to these needs by moving us subjectively.‡

As a feudal priest, Dubos, of course, was an antibourgeois conservative, not an esthetic revolutionary. But his thoughts on the arts illustrate the subjective and esthetic bias of feudalism that was contradicted by the rising merchant class's orientation toward objective logic.

Later in the eighteenth century, mercantilist logic and science attracted such thinkers as Jesuit-educated Denis Diderot, playwright, editor of the great Encyclopédie, and a leader in the French Enlightenment. By his time, France had had its Renaissance and its classical revival. Like the post-Tudor thinkers of England, Diderot opposed feudalism and its cultural collectivity in favor of individualism and unmediated naturalism. He attributed spiritual and moral concepts to the direct stimulation of the individual's senses. His bourgeois, naturalistic ideas excluded all ideological commitments from the arts and turned them toward an innocuous and homely concern with petty bourgeois life. He thus helped

*In K. E. Gilbert and H. Kuhn, A History of Esthetics (Bloomington, Ind.: Indiana University Press, 1953).
†Ibid.
‡Ibid.

the French merchants who were already seriously competing for power
with the feudal church, which held its rule through domination by
ceremonial arts.

In Germany, the traders' antifeudalism found expression briefly in the
works of such artists as Durer, Cranach, and Holbein. But bourgeois
humanism in that country was repressed again after the Peasants' War of
1524. While one "rebirth" of the procapitalist arts failed in its challenge
to the value system of feudalism, others were germinating. The esthetic
preconditions for the new rise of the bourgeoisie began to ripen again in
Germany in the eighteenth century. Then German theorists, in the words
of Gilbert and Kuhn, set out to "reform the national taste by carrying
attention straight back to the Greek well-head." They were repeating the
antifeudal propaganda of the Renaissance Italians, the Dutch and Flem-
ings, and the Tudor English, again citing the authoritative precedents of
prefeudal Greco-Roman arts against the medieval establishment. The
rationalizing and moralizing businessmen used the classical arts as an
arras behind which they and their anesthetics could lurk. In eighteenth-
and nineteenth-century Germany and Austria, the arts, especially litera-
ture and music, throve without much open bourgeois influence. From the
times of Bach and Handel through those of Goethe and Mozart to the
ascendancy of Bismarck, the arts were supported by patrons, and patronage
remained semifeudal (as it had in Renaissance Italy and Tudor England).
A living for working artists was generally in the gift of princes and prel-
ates, until the bourgeoisie took over completely. Then, as we know,
the bourgeoisie threw the artists out of the world of esthetically con-
trolled ceremonialism into the labor and commodity market.

Germany was still "backward," still feudal, into the nineteenth cen-
tury. Up to the time of Bismarck, the Iron Chancellor, Germany re-
sembled mandarin China in its social rigidity. Arnold Hauser says,
"Government posts were reserved, except for subordinate offices, for the
nobility and Junkers." Commoners were oppressed. The "peasants had
never known anything but serfdom and (by the eighteenth century)
the middle class, as well, lost everything they had gained in the fourteenth
and fifteenth centuries." With its neighbors to the south and east still
Catholic and feudal, the ceremonial and monumental arts remained
visibly on the scene in the Protestant parts of Germany. The music for
many masses and similar religious works were composed by Germanic
artists. As in the Italy of Vico and the France of Dubos, the presence of
surviving feudalism compelled the philosophers—who had also been
stirred by the bourgeois revolution in England—to give more theoretical
attention to the arts than had the spokesmen for the revolutionary
traders in the seventeenth century.

Nevertheless, the noise of the steam locomotive and the steamboat

made the industrial revolution audible around the world before the end of the eighteenth century. The rattling and whistling of the self-propelling and—with its feedback to the governor—self-regulating machine were the annunciation of mechanization and the prophecy of cybernation. Germany at that time was still a loose federation of semifeudal states and cities, an unsettled mixture of Catholicism and Protestantism. It could neither go all the way back to feudal art and religiosity nor surge forward to science and capitalism. Its philosophy had to bridge the gap, and a revival of idealism provided the bridge.

Idealisms have been intellectually potent in the West for 2500 years, and idealistic thought has paid special attention to esthetics. No major philosophical idealist from Plato onward has ignored the arts as the bourgeois empiricists and materialists—even many dialectical materialists—have so often done. Idealism, historically, has been a philosophical compromise between esthetics and logic. Such a compromise between the arts and the sciences could not altogether omit the arts.

The essence of idealism—the belief in objectively preexisting ideas—arose in minds created through the operations of illusion-projecting arts. Given this genesis, such beliefs are natural and inevitable. And, again naturally, these beliefs persisted until the esthetics of feudalism had generated its own contradiction in the logic of the traders, and until the subjective arts had nurtured the objective sciences.

Late in the eighteenth century, Immanuel Kant made the philosophical compromise between skepticism and belief that is called classical German idealism. He argued for a reality behind appearances, a "thing-in-itself." He thought that we must accept this reality although we cannot apprehend it rationally. For Kant, this nonsensible, "noumenal" reality coexisted with the sense-experienced "phenomenal." The former, he held, is known to us *a priori* and by faith. Even though the noumenal reality, like God, cannot be demonstrated by reason, we should think and act "as if" it could. Kant's philosophy, in actuality, advises us to behave "as if" the arts, from which come our beliefs in kinds of reality and in gods, did not exist.

Kant pointed to the contradictions of the finite and the infinite, of law and freedom, and to the mutually excluding but equally binding logical conclusions of the "antinomies." He thought that because reason is so self-contradictory, we are incapable of rationally knowing things as they really are. Kant went far toward evolving a theoretical compromise between esthetics and materialism. He came close to saying that the arts, too, give us a way of "knowing." But as a probourgeois philosopher, he naturally stopped short of basing consciousness and values directly on the arts.

Subjectively, and through the arts, man has created his gods and his

moralities and the "transcendental" intuitive or unconscious preconditions for conceptual thought. Awareness of this is alone enough to make idealistic spiritualizing unnecessary. The *a priori* or self-evident presuppositions, the things that are inherently or instinctively "known" in idealistic philosophies, are precisely what our arts have created and our cultures transmitted to us. Descartes and Locke were right: The mind *is* a clean slate at birth, a *tabula rasa*. But what is written on it is not objective experience, it is cultural experience, it is sensations immediately subject to interpretation and evaluation in a milieu prepared by the arts. We can be unaware of this partly because the feudal systems in our recent past have cloaked the powers of their arts in ceremonialism and religion. The antiesthetic revolutionary bourgeoisie of Germany in Kant's time could neither deny nor ignore the arts. In the compromising idealisms of Kant and others, bourgeois interests were served through fantastically ingenious systems of philosophy.

Schiller, Hegel, Schelling, and others, like Kant, used esthetically derived idealism to conciliate the declining emotionalized system of feudalism with the rationality of rising capitalism. Hegel pointed toward, but did not arrive at, esthetics as a synonym for dialectics. His formula was: being (thesis), not-being (antithesis), becoming (synthesis). Being and becoming are concepts of what is indefinable and incommensurable; that is, they are abstractions within the field of esthetics. Their limiting contradictory is definitive not-being. Nothingness is the logical limit and form of the esthetic context of existence. The necessary correlation of form and content produces the desired synthesis, without resort to the logical ambiguities of a becoming that is somehow different from being. The arts have given us our way of knowing. Esthetics is basic to epistemology, to awareness of existence and of reality. With art, we move from valueless classifications and definitions toward the feeling of life.

In their philosophical compromises, idealistic thinkers could do no more than approximate a correlation of esthetics and logic. They could not make such a combination real because their idealism etherealized the arts, carried them into the sky. The notion of ideal beauty came out of classical art, especially from its time-bleached statuary. It served bourgeois philosophy because it was ideally flawless; as pagan, it was ideally secular, and ideally irrelevant to eighteenth- and nineteenth-century life in the West. Ideal beauty, as a concept, was used by thinkers such as Winckelmann and Lessing in eighteenth-century Germany to justify the bourgeois social system. Classical art could not serve as a conditioning force in the practical interests of the merchants; its temporary revival merely provided the traders with an ideological stick with which to beat the church-bound feudal aristocracy.

In the late eighteenth and early nineteenth centuries, the successful

mercantilist powers moved on to the mechanization of their means of production. Industrial capitalism, even more than its mercantile predecessor, associated itself with the sciences. So, too, did its philosophy.

Where art was not or could not be twisted into an evolving, ever-changing commodity, it was minimized or omitted in the thought of science-oriented bourgeois philosophers. Friedrich Nietzsche was exceptional in being aware of the arts and of the art-science contradictions which the successes and pretensions of the sciences sharpened toward the end of the nineteenth century. The drive toward knowledge and scientific optimism, he said, had turned the arts from their course, and the arts could be reborn only when science had been at last pushed to its limits and, faced with those limits, had been forced to renounce its claim to being all-inclusive. Nietzsche was art-conscious, but he saw the importance of the arts only through the class conceptions of beauty. In the classical revivalist tradition of bourgeois philosophy, he turned for precedents to Greek art, although in many respects he was vehemently antibourgeois. He did not see how inescapably a positive or negative attitude toward the arts is forced on the people in all class societies. The herald of this truth was a man who, in his writings at least, paid little attention to the arts: Karl Marx.

In his materialism, Marx rejected the idealistic compromises of Hegel and of Kant. In his Hegelian dialectics, he rejected static logic. The resolving philosophical synthesis, dialectical materialism, presented in his writings and in his life, put aside the religions of feudalism and tribalism while carrying forward the essence of the esthetics on which they were based: the insistence on values for the masses of the people. Marx was on the side of humanity and in this at least he was on the side of esthetics as against bourgeois rationalism.

In the social struggle going on in still feudal Germany, Marx was as much anticapitalist as antifeudal. While Marx accepted objective science and industrialization, he repudiated everything else that was bourgeois. Like most other Western philosophers, he did not specify esthetics as a primary factor in theory or reality. But he lived an actively antibourgeois life, esthetic rather than logical, warmly emotional rather than coldly rational. He was motivated by commitments to nonrational values, and revulsion toward "all relations in which man is a debased, enslaved, abandoned, despicable essence, relations that cannot be better described than by the cry of a Frenchman at a planned tax on dogs: 'Poor dogs! They want to treat you as human beings!' "

Marx saw himself as a rationalist rather than as an emotionalist, but his life may best be read as a sustained esthetic-moral act.

The discipline of science is formal—not dialectical—logic, and such logic is measuremental and definitive. When definitive logic is turned

by man onto his fellow men, it finds the most readily measurable products of human activity in the field of the "dismal science," economics. The attractions of successful natural science, in addition to Marx's sympathies for those who worked in barracks and lived in rent-wracked warrens, turned him, the emotional revolutionary, to economics in order to use the terms of science in attacking the bourgeoisie on behalf of the proletariat.

By suppressing the mass arts, the bourgeoisie was able to impose the objective measure of money on life, labor, and commodities. In reaching for "scientific" objectivity, dialectical materialism endangered its dialectics. The quantitative "labor theory of value" was designed by Ricardo to serve capitalism. But the valuelessness of quantitative measures when applied to cultural products shows up immediately when the idea of measurable labor or exchange value in any art work is challenged. What is the dollar cost or objective value of the labor expended in producing a Taj Mahal or a sonnet?

Art creation is work without which there could be no cultures. While it is obviously true that man cannot live without bread, it is also true that cultural man has never lived by bread alone. True, too, is the fact that material and cultural surpluses created by workers in class societies are taken from the workers, as Marx has pointed out. But these expropriations were unresisted only because the arts had long before created the cultures within which such dispossessions could be sanctioned. The feudalists had done this by concealing the arts in religion. The capitalists carried the process to its limit by depreciating the arts in favor of economic and political force. Marx's scientism led him to bypass the arts as a primary source of knowledge and consciousness. But his inverted Hegelian dialectics, his materialism, and his revolutionary feelings saved him from esthetic quietism, as they kept him from airy idealism and from the deep freeze of static logic.

The Kantian antinomies and the Hegelian-Marxian contradictories of free will and law, freedom and necessity, do not abolish each other. They coexist in spite of the proscriptions by formal logic of whatever is undefinable. Science is objectively realistic where art is illusionary. But art is also cultural man's abstraction of motion. And motion, through which we realize freedom, is as real—and as unreal and as abstract—as is measurement and definable position in scientific thought. Art and science do not cease to exist when circumstances drive one to denying the other. Marxism, in its moral sense, seems to approach a synthesis of art and science that is needed for the perfect philosophy. In moral Marxism we can reaffirm man's ages-old esthetics and correlate it with modern technology and science.

XI
ART AND SOCIOLOGY

The social sciences are, supposedly, studies of man. Since man is eminently the art-making creature, it might be expected that these studies would try either to make a bridge between art and science or to encompass esthetics within some broad logical view. Rather than treat man as the art-maker, however, the social sciences stress their allegiance to science and pay less and less attention to the esthetic side of human life. Today, in texts on social science the arts are usually ignored.

For these studies to pursue any other course would, admittedly, lead to difficulties. In a research project for a pure science such as physics, human beings would be viewed as objects, without prejudice and unfeelingly. They would not be as the artist sees them, empathic subjects. In an applied science, which is a sort of human engineering, human beings would be studied as things to be controlled, not as fellowmen to be freed of limiting controls. Emotions would interfere with objectivity, art would get in the way of science. And yet, the only key to the subjectivity of the art-maker, man, is his art, which cannot be treated objectively or scientifically. An art work exists only as a relation of illusions between actor and audience, sender and receiver. It is not definable. And man, considered as the maker and acceptor of value-charged illusions, is equally inaccessible to definition.

Why social "science" at all then? Why the illusionary attempts to define the illusion-maker? The answer continues the story of the traders' struggles against the religious-ceremonial mass arts of feudalism. From the beginning, the mercantile capitalist's aim of controlling the people through money was supplemented by his propaganda for objective logic. To replace feudalism's control of people through the arts, traders in ancient Greece developed money control and rationality as defenses of their unemotional objectivity and as criticisms of ancient feudal esthetics. Later, in Western Europe the bourgeoisie revived and further developed objective and scientific logic as propaganda with which to oppose the agriculture-and-art-based feudalism of the Church. Since then, industrialists, using modern technology and science, have superseded the merchants as the dominant class in the capitalist nations. In parts of the world, this combination of money and scientific logic has transformed the means of production through the industrial revolution. But during

most of this revolution, the relations of production and social relations have remained generally unchanged in the capitalist nations; that is, money is still the principal instrumentality through which the behavior of the people is controlled. However, the momentum of the drive developed by mercantile-capitalist logic against feudalism and its religious esthetics has carried over into the period of industrialization. This momentum has propelled the effort of the bourgeoisie to rationalize man's subjectivity through the social and behavioral sciences. Where the natural sciences could anticipate material events and profitably regulate the mechanics of production and transportation, these later sciences—it was hoped—would take the measure of man so that his behavior could be predicted and controlled. And in the twentieth century, the question of how to control people has become all important to industrialism. When industrialization transformed the means of production, it did away with the scarcities of money and goods on which capitalism's power rested. Money power, as we can see in many places around the world, is being fatally weakened whenever the possibility of general affluence arises. It has become vital for the bourgeoisie to keep a watch on mass subjectivity in order to be forewarned of possible mass action.

The bourgeoisie may have reckoned on some such weakening of its money power as early as the mid-eighteenth and early nineteenth centuries. From the beginning of the industrial revolution, theorists of capitalism were looking for alternatives or supplements to the power over their fellow citizens that money gave them. Police forces have provided an answer.

When the hold of feudal arts in Western Europe was loosened by mercantile wealth and by the revolutionary bourgeois revival of classical arts, feudalism resorted to force to hold its internal political power. For a time, inquisitions, civil wars, massacres, and armadas threatened all the trade-oriented European communities. In the nineteenth century, anticipating revolutionary contradictions to its own power similar to those with which it had challenged feudalism, capitalism recruited—well in advance—a home guard against its people.

Early in the Age of Industrialization, the bourgeoisie set up the domestic counterparts of the professional armies it used to take colonies and to make wars. In 1829 in England, about the same time in France, and during the Civil War in the United States, capitalism begot the world's first specialized, full-time police forces. These were a new fighting arm, designed to maintain bourgeois peace and to occupy the home territories, holding them, if necessary, against their inhabitants. With the police, came more judges and lawyers. This has been called an "explosion of advocacy." The number and size of prisons increased. It has been ob-

served that the cityscapes of the English Victorian period were notable architecturally for the imposing new jails.

It was applied science, the technology of industrialism, that made this show of force necessary. When the applied sciences together with business produced industrialization, they also brought about the threat of affluence and the demand from the people for something more than mere subsistence. These demands were ominous in the ears of the bourgeoisie. The businessmen encouraged the social sciences which by extension and analogy would have the same relation to man and his activities that the natural sciences had to the objective world and the new industries. The intermediation of the engineers and technicians who were applying science to production was the shining example. But the only social counterpart to be found for the engineer, the controller of mechanical action, was the policeman, the controller of human action. The policeman's club was to bourgeois social engineering what the centrifugal governor on Watt's steam engine was, and the computer in today's industrial complex is—to industrialism's technology. In class societies today, police work is applied social science.

Without police help, the social sciences could not even attempt to carry out the task of controlling the behavior of whole peoples. In fact, something more persuasive and more relevant than the social scientists' reports on animal behavior and human neurosis, and more forceful than the policeman's club is needed for such an immense and important task. The arts, as they have shown throughout man's long existence, have the power to motivate and culturally condition human beings. The choice is between having police everywhere and having art everywhere. And, paradoxically, social science, "science" applied to humans, turns out on critical inspection to be art disguised as science.

Therefore, the corrective way to look at the social sciences would be to view them as arts. In typical social-science experiments, subjects are led into situations borrowed from stories or dramas. The prestige of the art-hero has been conferred on physical and biological workers for their achievements. Experimenters investigating the human soul have borrowed the title "scientist," and they then put themselves and their subjects through productions that invariably reaffirm the esthetic motive in human behavior and the esthetic base of human consciousness and man's cultural existence. At Yale University, experimenter Stanley Milgram organized what can correctly be called a small theater and, beginning in 1960, he put his assistants and volunteer subjects through a set of illusionary situations which the volunteers alone thought were real. They were asked to aid in tests designed to measure the learning abilities of people under stress. The persons to be so measured were, they thought,

volunteers like themselves. But these supposed "guinea pigs" were, in fact, part of the experimenter's staff. The innocent volunteers were instructed to administer electrical shocks to the supposed learners. These jolts increased, by stages, from 15 volts to 250 volts. At the orders of the prestigious experimental "scientist," the volunteers continued to inflict what appeared to be painful and, in some cases (they were told), possibly fatal charges of electricity. In this theatrically contrived situation, these ordinarily good human beings disregarded the seeming agonies through which they were putting fellow humans, because prestigious science, using art, urged them to do so.

When social science disregards its esthetic base and objectifies its human subjects, it first deculturates them and thus dehumanizes them. Shortly after the Attica Prison rebellion, troublesome prison inmates found themselves directed by psychiatrists, who had the cooperation of the wardens, into situations of extreme loneliness and sensory deprivation, absolute isolation. After a period of such sensory deprivation, the subjects of this treatment were to be rehabilitated in a reward-punishment course. Uncooperative behavior meant continued "solitary," while "reinforcements" for good behavior would operate through the restoration to the subject of permission to hear, speak, and return to the cultural life—such as it was—of the prison (Newsday, August 30, 1973; New York Review of Books, March 7, 1974).

Economics, alone of the social sciences, can deal mainly in quantities rather than qualities—however much we are put out of touch with human existence when suffering and surfeit are reduced to the economist's numbers. The subject matter of the other "sciences" is—or properly should be—more esthetic than scientific, more humanly subjective than materially objective.

Practice in sociology, psychology, politics, history, or education is practice involving the arts. Measurements and formalisms are less important in these fields than creative interpretation and inspirational appeal. When the strictly scientific archeologist has fixed his dates and arranged the sequences of his "artifacts," his work is done—and dead. He leaves it to the reader of his reports, or to a popularizing rewriter, to fill in the epic comedy and tragedy of Australopithecus' efforts to cultivate himself. After the anthropologist has made his charts of tribal relationships, he must become an artist to make his observations come alive. Men, women, and children when seen as objects lose the distinctive attribute of their reality: imaginative cultural life.

When pseudoscientific, the social studies are antiesthetic rather than neutral. They hold humane commitments in a rationalistic straitjacket. They serve to paralyze the mass arts by preempting much that is indis-

putably emotional in the name of "reason." When esthetic theory is united with social practice, we will begin to "know" how human beings organize themselves emotionally. Then we may organize for specific tasks without enlisting for life under any fixed belief, and without falling prey to the suspicions that spring up in such groups and around such groups between insiders and outsiders. We may then understand how our beliefs are generated and how to create and dissolve our social organizations.

XII
ART AND PSYCHOLOGY

When psychology uses a scientific mirror to look into the mind, silvered glass reflects silvered glass. It sees nothing but itself because the mirror of science cannot reflect the magical phantoms of the arts. The subject matter of the mind—man's supposed instincts, his imaginings and emotions, even to a large extent his personality—are not objectively real. These things come into being in his relations with the arts and can be comprehended only in that insubstantial connection.

In what has gone before, I have tried to show that man created his cultures by means of his arts. Without arts he could not so readily project and accept illusions today. And he could not in the far past have developed concepts of the *unreal* and thereby create critical notions of what is *real*. Without arts he would have had no make-believe or alternate selves to use dialectically in forging his self-conscious individuality. He would not have had the kind of mind he has, or a "science of psychology" to bother his mind about. It is not strange, therefore, that the subjective realities of his cultural being are found to be accessible only through the arts.

If we do not consider the arts, we have no key to our subjectives. Our evolution toward an exceptional degree of adaptability has left us relatively free of the compulsions of the ethologists' "action-specific energy." We do not inherit many fixed behavior patterns that drive us reflexively to flight or pursuit, to food or sex. A healthy, maturing human being has energy enough for these things, but few or no behavior patterns that can be activated without instruction or learning. We are driven by what we experience at first as nameless desires. We recall these throughout our lives as infinite longings for the unattainable and the unthinkable. A "flood of laboratory studies" show that the newborn child "starts life with only vague emotional responses," according to the *International Encyclopedia of the Social Sciences*. The infant comes to feel fear, rage, and unspecific feelings of love at three months, and to feel love for its parents at six months. Other emotions, according to Mary K. Harlow, appear in childhood, adolescence, and adulthood. We may suppose that since the baby "knows" hunger, as reflexive sucking suggests, and soon knows or learns of the need to breathe and perhaps to move its limbs, it has such early urges in a single unsorted package of amorphous desire.

111

P.J

This undefined desire is the only ready-made feeling with which we are endowed.

As the infant grows, its generalized desire is turned in the presence of the arts into specific emotions and appetites. And not the least among these appetites is the unconscious need and longing for arts. The empty mind is as blindly ready for arts as the empty stomach is for food. The infant's unshaped desires must be cultivated as carefully as his body is nurtured. In most societies, the child is encouraged to react and act. His attention is summoned daily, repeatedly; it is beckoned toward the light of feeling and understanding. It is directed artfully toward cultural consciousness. In ancient China, Chuang Chou asked, "What is the cause of emotions? It is near to the truth to say that without them there is no 'I,' and without an 'I' they have nothing to take hold of. But we are ignorant of what makes this so."*

Through the child's long years of growing, the strong, amorphous drive of desire flows into the many channels of specialized feeling that are prepared and elaborated by the arts. The human personality emerges as the boy or girl grows up in the reflex-conditioning system that has been produced for this purpose by ages of art. The human child is persuaded by his art-conditioned parents to respond to their artful behavior. They act out laughter and love for the child until he, too, performs and learns how to feel culturally. Art-induced emotional tensions and release from tensions, stimulations, and rewards experienced over and over again in esthetic illusions make of each of us the kind of person he is going to be.

The plastic blank that is the human mind accepts the abstractions of emotion and reason because it cannot do otherwise. It is a mind, and it is blank. It is ready to receive images, signals, signs, symbols, and the other illusions brought into service originally through the arts. It should be a truism that since we depend so directly on our arts, any understanding of ourselves requires an understanding of the arts. But our ideas about the arts have been thrown out of gear by capitalism's systematic reduction of the arts to random fragments and unrelated submovements. The merchant-rulers' conversion of everything salable into commodities has atomized culture into art works. When we think of art today, we think of this, that, and the other piece of art and forget that all earlier human existence was immersed in mass arts and in the organizing values of their esthetics.

The fragmentation of the arts carried with it the isolation of the masses of men. Throughout the ages of feudalism, men lived under the

*Quoted in E. R. Hughes, ed., *Chinese Philosophy of Classical Times* (New York: Everyone's Library, 1954).

rule of the arts rather than the rule of money. If today the mentally healthy suffer in self-respect as they are crowded out of useful work by competing machines, and are isolated spiritually by the disconnection of the arts, the mentally disturbed are so much worse off in their estrangements. In delusions, desire moves a cultivated imagination that is lost in itself. These diseased illusions are sicknesses of the values created by the arts to move men purposefully in real situations. In delusions, the subjectivity engendered by the arts may become ingrown, self-preserving, and self-sealing.

When the social art-creator is driven into such isolation, he performs and responds within his own mind. If he creates feebly and is poor in performance, as he usually is, this adds to the sadness of his condition. The objective and logical parts of his adaptable consciousness having already fallen away, leaving only the esthetic part, the emotionally sick person is locked into the conditioning processes of make-believe. He continues to be moved by nonrational drives, while he has lost touch with the objectivity and with the rationality that could limit, help to release, and, momentarily, satisfy his desires. Desire is not self-limiting. Emotionalized subjectivity may seem to be infinite to the detached individual, but if it is rationalized objectively it becomes recognizably finite. A desire expressed and acted upon can be brought to an end objectively. The momentary ecstasies of sex, for example, are limiting definitions of desire, as logical an end to longing as death is to life.

If the world defeats a man, he may be driven entirely from objectivity into the concentric self-stimulation of total subjectivity. Or he may complete the negation of esthetics as well as logic by responding to neither inner nor outer stimulations. In the illusionary-delusionary world of mental illness, the ready imagery of the arts may suggest to the sick person that he recreate his own personality. Using the licensed make-believe of art, he borrows an impressive figure from the cultural store, makes a new self to fit it, and moves into it. But the madly illogical esthetician cannot be secure in his borrowed personality. Somewhat like other artists, he is driven to seek approval and support, or at least mere toleration. Failing these, he retires into a tragic simulation of the lonely creative worker.

The waking sleepwalker is thus artistically, but not scientifically, accounted for. Three mad Christs were confronted with each other in the state hospital at Ypsilanti, Michigan, in 1963. When the relentlessly experimenting psychiatrist brought the rivals together, each of the two oldest men said the others were pretenders. After some struggles for recognition, the third and youngest patient gave up his messianic role and retreated further from reality into other protective fantasies. He created for himself a rather mocking and original identity, one without

readily identifiable cultural ancestry. He became Dr. Righteous Idealed Dung. Here one mad artist, under pressure, changed the script, so to speak, in order to preserve the creative delusion of otherness that apparently was necessary to him.

It is dramatically predictable that the refugee from reason, deluded into imaginary grandeurs, would desire to see himself as the center of flattering or hostile attentions. But what would happen to him in a culture that did not have the Western plot-drama or Western history? No study has been made of the specifically cultural content of any madness, preliterate or literate, primitive or sophisticated. Does a mentally sick Asian imagine himself to be Napoleon or Genghis Khan? And in general, what differences of esthetic content are there in the imagery of madmen of different cultural groups?

A significantly final kind of mental illness is characterized by a total negation of esthetics. It is an exhaustion or abandonment of reactiveness. The complete failure to be moved ends illusory and delusory art, as well as physical activity. Pavlov, for instance, reported the case of a man who slept, like Rip Van Winkle, for twenty years. This lethargy is the final pathology of the arts, stuporous insanity. If the threatened person is unable to live in his waking delusions, the burden of cultural consciousness may be put aside as he falls into pathological sleep. He may drift into "the doldrums," suspended endlessly in some Sargasso Sea of the mind, when the propulsion of esthetics is spent. A deep stupor, a sleep that can last years, may result, if for him the arts have no effect. When the demented nephew in the play *Arsenic and Old Lace* was forbidden to be Rough Rider Teddy Roosevelt, he crawled under the bed and refused to be anybody. The difficulties of establishing and motivating an identity, its likelihood of splitting and of being obscured and lost, reemphasize the cultural contingency of our consciousness and the dependence of the mind on the abstractions and impulsions provided by the arts.

The grip of capitalism has so distorted the arts that it becomes an act of insubordination to point to bourgeois misrepresentations of esthetics and to contradict them. In the English-speaking world of the last century, John Ruskin, William Morris, and Havelock Ellis were among those who challenged this misrepresentation of the arts. However, they did not look forward to industrialization. They could not comfortably put mechanized production in the center of their dreams. Consequently, they could not project a vision of the technology that would give form to the mass arts of the cultural revolution. Their vision remained individualistic and technologically conservative.

In Freudianism, the arts are looked upon as effects and as expressions of instincts, not as the socially causal instrumentalities that they are. The obsessive Oedipal relation did not inspire or lead to the myths from

which the name is taken. On the contrary, these myths and the later Greek plays helped to create the social relationship of dominant father with subordinate wife and son. The patrilineal family was invented or renewed by the artists of the time to displace a defeated matrilinealism. Art demoted the Great Mother, in all her various manifestations, to secondary place in the pagan pantheons and to the human Mother of God in Christianity. Today's drama of Oedipus is not the blind struggle with fate and instinct played out in ancient Thebes by King Laius, Queen Jocasta, and son and usurper Oedipus. For us, in the wake of great industrial change, the more appropriate meaning of the story is that of a cultural, rather than a dynastic or economic, revolution. The familial relation of slave-trading father, the master and owner, with mother as possession and son as rival and potential thief, was peculiar to the early mercantile-capitalist world and was designed to fit that world. Today we see objective economic imperatives blindly reaching for the subjective cultural sanctions and the motivations of the arts through which alone new social relations can be made to work. Freud showed us individual minds hurt at being torn out of the esthetic matrix of consciousness.

Property-minded bourgeois psychology read ownership into the sexual problems of Oedipus and of mankind. And it saw sex before, apart from, and without the arts. The bourgeoisie, having overthrown art-dominated feudalism, could not choose the arts as conditioners of behavior; hence, they have had to declare sexuality to be instinctive. Yet, since all men and women are cultural, it is manifestly impossible for them to look at their world or at each other in a literally artless way. They cannot take in any scene, they cannot see each other apart from the long conditioning by the arts that affects all their acts, including the act of looking. "Is she pretty?" "Is he handsome?" are not scientific questions. This is not to deny that people may see one another partly as material and biological objects and as symbols of property and status, but they also—and primarily—see each other as subjects projected by the arts.

The scene in which people meet, and the human actor-beings in it, is often art-produced, and it is always interpreted esthetically. There must be culturally significant costume, furniture, architecture, land- or city-scrapes. Or if these are absent, the scene takes its cultural character from the people's art-created responses to what it is. In a theater, nude figures or a bare stage or both together take meaning from the cultural context in which they are presented. All that is visible and audible in life has long been schooled by the ever-present arts, although in bourgeois psychology the arts and emotions remain suspect. Adolescents today openly and irrepressibly make the transposition of sex into the art-created sentiments of love. Youths carry portable radios that sing of almost

nothing but love. Near-grown boys and girls try out every art form that may stimulate love and ready them for it. They make or wear or transmit gestures and attitudes, costumes, body paint, words, abracadabra, and chants that are intended to be sexually moving. They are getting ready to challenge parental bourgeois logic with revolutionary esthetics.

Much of this, we may be told, is play and therefore not to be taken seriously. However, the eighteenth-century German poet-philosopher Friedrich Schiller said that play was one of the three great forces in man's life. The other two were form (*Formtrieb*) and materialistic sensuousness (*Stofftrieb*). Play for Schiller included esthetics, an idea later borrowed by the Victorian English theorist Herbert Spencer. Art described as play seems a moderately derogatory classification of esthetics, a disposition likely to please the antiesthetic bourgeoisie. But though always illusory and imaginative, the arts are not always playful. The mass arts of monumental ceremonialism were seldom merely amusing. Servants and slaves were buried with dead god-kings. Faith, in medieval Christianity, could lead to the monastery or the hermitage and lifelong asceticism. The loser in an Aztec ritual ball game might thereby lose his life. In these art-dominated cultures, illusion and reality, art and science interpenetrated. Esthetics was the most serious matter in the world for the artist-priests, and its illusions were, of course, what the trader guarded himself against first of all. In later bourgeois society, art and play have been almost equally inconsequential—except when they were practiced successfully for money.

The play aspect of sex, especially the "foreplay" leading to the sexual act, has been given some attention. Havelock Ellis called it art, part of the "dance of life." But for the conventional bourgeois mind, even when allowing that sexual play might be entered into by adults, play remains frivolous, unnecessary. And, to the trader intelligence, play is less dangerous than art. It is as if saying "fun" and "make-believe" rather than "art" could save bourgeois logic from esthetics. But the question, "What else is play but the make-believe of the arts?" may be answered with: "What else is healthy human sexuality but an aspect of esthetics?" Imagination, illusions, and art-based values intrude. Hardheaded bourgeois Samuel Pepys eagerly listened to tales of the king's sexual affairs. One day he caught a glimpse of a supposed mistress of King Charles II, "with her hat cocked and a red plume, with her sweet eye, little Roman nose, and excellent *taille*." That night, in bed with his wife, he imagined himself "to sport with Mrs. Stuart with great pleasure."

In a John Osborne play, described by Kenneth Tynan, a young couple congratulate themselves on their marital good fortune. Both find sexual release in acting out a fantasy that involves a common plot item in

Edwardian farce, the seduction of a French maid. Art and make-believe, fantasy and illusion gain relevance from the recurring exclamation, "What does he (she) see in her (him)!" In Kingsley Amis's *Take a Girl Like You*, the girl sees some young mothers waiting for their children outside a school. She wonders how anyone could sleep with them. "They looked—the thing had to be faced—much too horrible." But for how many years will her own lover or husband stay "in love" with this girl? How will they manage emotionally when they get "horribly" old, at, say, thirty, forty-five, sixty? Must he (or she), enjoying sex for the second or the thousandth time, begin to wish—or to imagine—that it were with a different partner?

What is subjective reality, what is make-believe? What is normal in human sexuality? Is it to be determined quantitatively by a statistical biologist such as Kinsey? Or by an objective set of facts established by technological voyeurism, such as that of Masters and Johnson? Is it normal to experience sex with 1200 different women, the assertion of the Victorian author of *My Secret Life*, or with the thousand different partners attributed to the legendary Don Juan? Or is it more nearly normal to mate with a few score, several, or just one? For a creature who makes his own value systems and fabricates his social environments, there are no norms but those he is responsible for creating. And he can do this only through his arts, not through psychology or any other science. Art is the main component of the imagination and of our sexuality, just as it is part and parcel of all human cultures.

The objective world existed before man appeared and it may continue without him. But his wonderful subjective world has come into existence with his cultures. It depends on the imaginative arts and on his cultural interpretations of his personal experiences. The unclassifiable variety of fantasies in the imaginative life of man matches the freedom he exercises in his arts. Nietzsche said the dreamer was the perfect artist. Comparing the diversity of dreams to the apparent regularities of the objective world, Heraclitus observed 2500 years earlier that while the waking all live in the same world, in sleep each of us turns aside into a world of his own. We realize today, however, that we are seldom wide awake. We know that fantasies peculiar to each of us come and go in the streams of our waking consciousness as well as in the deep unconsciousness of our dreams. We daydream as we work, as we travel, as we wash or eat. Whenever our attention is not engaged by unusually demanding physical or mental efforts—or by arts—we muse or we "think." In the reveries of free association, desires and wishes that have been declared sinful may pass the censorship of our waking conventionality. And in dreaming sleep, strange and familiar shapes move with us as we

are drawn along by rationally unknowable forces. The art-born, emotion-charged contents of our cultures, freed in daydreams or in the dreams of sleep from the harness of reason, run unchecked.

Here logic and science cannot govern. Whenever we relax, it is the scientist who sleeps. And yet we are not left utterly without self-controls. We do not drift altogether helplessly on the tides of our dreams. In the matrix of the imagination, that is, in our arts, our fantasies are subjected to cultural rule. What we may desire and what we ought to dislike are determined for us in our cultures and implanted in us through the pseudoexperiences of the arts. The propagation of such values is visible on every hand. Daily we see how some arts and the values they carry are spread throughout a society. They circulate new desires or re-affirm old and dissident beliefs to the members of the social organization. Cultural revolutions are the struggles for transmission and acceptance of the changing values that are conveyed by the arts. And in these, as in physical struggles, there are individual casualties.

Psychopathologies are evidently pathologies of man's art processes. Whether these are also caused by biophysical imbalances, such as mal-functioning of glands or nerves, or are accompanied or followed by bodily changes is beside the esthetic question at issue here. Treatment from the physical side, when it may be established, will certainly be the legitimate concern of medical science. But the facts of definably material bases for health or illness could not eradicate the nondefinitive content of the mind, whether sick or well. A restoration of chemical balances in an esthetic organism leaves the individual's maladies untouched. The pharmacist may put us to sleep or wake us, but he cannot concoct the stuff of our dreams. And he cannot create our motivating values. "The human heart is not a bag into which one can plunge one's hand," says a Kongo proverb (Ruth Finnegan, "Oral Literature in Africa," *Times Literary Supplement*, April 23, 1971).

When the mind of the individual is stricken, he begins to live altogether in an art-haunted dream state where emotion is severed from reason. Pathological delusions are fixated illusions, hyperfantasies of guilt, fears, and desires. These are moved by derelict esthetics which has broken loose from the moorings of established logic. Rational barriers may fall when overcharged emotions blow up a storm. The victim may be marooned on some lonely, vision-plagued island of consciousness. The energy of fear and hate, of determination and hope can be harnessed to action, or it can sweep away reason altogether.

The modern separation of the rational from the emotional goes back to the origin of writing and the beginning of trade. The definitive aspects of thought were crystallized in the writing and logic of the early traders. This gave their successors by two-and-one-half millennia the idea that

thought is best expressed in words and numbers and that thought itself consists of these symbols. Other modes of apprehension, reflection, and communication, which had served for a hundred millennia before, were put aside when letters appeared. Colorful, tactile, kinetic, textural, pictorial, and musical expressions were viewed as inessential to thought. This is where Herbert Marcuse's "one-dimensional" and Marshall McLuhan's "linear" men were foreshadowed. With the recession of the nonverbal, much of man's sensory experiences took place below the threshold of his self-awareness. The fixating symbols of written words and numbers came to represent all knowledge. There can be no doubt that writing has served man well, but in the hands of the traders it also was used to narrow his consciousness.

It remains for the arts, which relate to man's whole sensory existence, to show man the way toward his emotional and rational reintegration. The therapy of healthy mass arts may or may not cure the mentally troubled, but the social hygiene of an esthetic revolution would at least provide a better environment. And full art therapy under modern conditions has yet to be tried. Pavlov and his followers have shown us something of how animals acquire habits and learn, and of how complex nervous systems operate adaptively. Now, art, the reflex-conditioning vehicle that carried a manlike creature from life as a cultureless hunter-gatherer to life as man, must be called upon to reintegrate the human being.

XIII
TOWARD
THE ESTHETIC-CULTURAL
REVOLUTION

Today, in the United States and a few other countries, industrialization has made a comfortable living possible for everyone in these countries. Tomorrow, industrialization can provide this comfort for everyone, everywhere. The use of dollar-control in place of art-control stands in the way of wider industrialization: If everyone were assured of a good living, fear of being poor would disappear and with it, money as a means of social control. Exclusive one-crop production and raw-material supply are imposed on colonial countries by capitalism. At home in countries such as the United States, capitalism, in its nature as private enterprise, also prevents an equitable distribution of what is produced.

The task of today and tomorrow is the creation of a kind of society, so far, only visualized dimly. In this new society, scarcity must give way to sufficiency as the mainspring of economic policy, and the individualistic businessmen must be replaced as administrators of the society by their opposites, art-men. These creators of cultures will use the entire social environment as a medium for the arts through which they will direct themselves and all men, organizationally and emotionally.

These arts will be mass arts, the arts of all members of a society, as distinguished from the class arts which have been designed, especially in bourgeois societies, for a few and restricted to these few. Tribalism and, to a less degree, feudalism were organized around their own kinds of mass arts. Every child in a tribe was conditioned by its arts. Belief was unquestoned, and participation in the arts was universal, except for the divisions of labor based on sex and sometimes on art skills and priestly status. In art-dominated feudalism, beliefs were shared by all, and some active participation in the vital art ceremonies of the societies was general. Restrictions on participation in the arts came with the revolutionary traders and their exercise of social control through money. Their development of writing and the transformation of education into a commodity eventually restricted the full experience of the verbal arts to the literate classes. The other commodity arts, too, were restricted to those able to pay for them.

121

Easel paintings are one of the clearest examples of art as private property. These paintings can be taken out of the general culture altogether and hung in closed chambers. That in the twentieth century many have been returned to public view does not alter the decisive fact that all original works in the bourgeois period were created as—or were immediately turned into—commodities. They were brought onto the market to shore up bourgeois individualism and to attract private buyers. In the museums, the public is allowed to view—but not to participate in—the capitalization of this art. Mass arts and individualistic class arts are polar contraries. This has become most clear in our industrialized arts. Since radio, television, the comic book, and, to a less extent, other printed matter can go everywhere, they are mass arts in form. But in content they are individualistic class products. Money control contradicts mass participation in and mass control of these mass arts. Man's experience of the arts generates his beliefs. The experience of endlessly varied, anarchic-individualistic arts, that is, bourgeois arts, produces our characteristic ideological confusions. It turns the viewer from the prospect of mass belief and mass organization through the arts, to disorganization, and reinforces the control of money power over the people.

There are numerous signs today of contrary and revolutionary trends, signs pointing toward the renewed use of the arts as the prime means of social organization. The emancipation of the trader meant disinheritance for the artist. The creator of cultures and of epic wanderers was himself threatened with a kind of homelessness. From the beginning of trader power and the founding of the mercantilist nations, the artist has felt himself to be rootless. Now, since the spread of industrialization especially, art and the artist have emerged from isolation to take a central place in the social scene. And in this emergence, they have a new self-consciousness. For the first time in the human record, the creators of art and their creations have themselves become the subjects of art-creation.

In this, a subjective revolution has been under way. Art, as the necessary correlative of science and industrialism, has become the specific contradiction of the bourgeois way of life. The change to self-conscious art-about-art has had the ultimate effect of transforming art from the isolated activity of a few, as it seemed to be under the traders, into the central concern of industrialized man. From being an oddity and an exception, the artist is becoming the typical human. Potentially, now, art is to be produced by everyone, and the artist is a projection of Everyman.

In using the arts for sustained self-portraiture, the artists have changed the identity of mankind. In an ideological transformation already marked in the industrialized communities, they are in the process of moving the

people over from the nonesthetic commercial materialism of the bour-
geoisie to the dialectical materialism of the esthetic-cultural revolution.

In the feudal and primitive past, art and artist were seldom the sub-
jects of art. Artists usually remained unseen within their works. The piper
and harpist were mentioned occasionally in song. The name of Imhotep,
an Egyptian pyramid designer, was recorded and has come down to us.
Esthetics was reflected symbolically in the Muses and in Orpheus and
Apollo. Nevertheless, art was almost always anonymous. It was unself-
consciously magical or sacred until its desacrilization by the traders.
Business and individualism arrived hand in hand, and with individualism
came the individualistic artist. Homer got as much attention as some of
the heroes of his epic poems. Sappho was a self-dramatizing personality
as well as a singer of love. When the antitrader resurgence of feudalism
set in, playwright Aristophanes, in *The Frogs*, complained that playwright
Euripides was so crass as to put on the stage "things that come from daily
life and business," and admired playwright Aeschylus, who did not do this.
Plato called the poets "unruly," which may be read as "individualistic";
Aristotle classified them and their works as he also classified plants and
animals. With the return to a measure of art control of behavior under
feudalism in late Greece and in late Rome, and to almost complete art-
domination in the late Middle Ages, the artists retired once more behind
their works.

After a thousand years, feudalism again began to give way to trade,
and the arts reacted to renewed depreciation by reasserting the artist's
individuality. Vasari wrote lives of painters and sculptors. The "genius"
was invented or resurrected. Plays within plays commenting on art within
art appeared, from *Hamlet* to *Six Characters in Search of an Author* to
Marat/Sade. The poet-author walks throughout *Ulysses*, and in *Finnegans
Wake* art, sleep, and history are disappearing into art. The baffled
movie director in the film *8½* puzzles over the picture he is in the
process of producing, and there is the teaser of finding director Alfred
Hitchcock's face in each of his pictures.

William Blake proclaimed the arts prophetically. Walt Whitman
trumpeted poetry and himself as poet-prophet. Browning poetized over
fellow artists Andrea del Sarto and Fra Lippo Lippi. Consciousness of the
artist as worthy of the most serious attention, if not as the agent of
revolutionary subjective change, animated innumerable modern works.
Among them were the self-portraits in Ibsen's *The Master Builder*, Strind-
berg's *The Creditor*, Proust's *Remembrance of Things Past*, Joyce's
Ulysses, Maugham's *Of Human Bondage*. Samuel Butler, George Gissing,
and the soldier-writers of two world wars recounted their own life ex-
perience as if it was fiction.

When the esthetic worker and the esthetic product became major

subjects of nineteenth- and twentieth-century Euro-American art, it was a recognition by artists and audiences of the value famine destined to spread throughout the bourgeois social structure. In the bourgeois era, the frequent appearance of the artist as a hero in art and in life shows up sharply the absence of social leader and businessman from this role. The arts of other times gave their typical leaders—hunters, warriors, saints—their charismatic powers. Prehistoric myths acclaimed the all-giving mother, the ordeal-enduring male, the courageous adventurer. The myths of feudalism glorified the saint and the knight. In the arts of the industrialized capitalist societies, the social leader, the capitalist is almost altogether missing. When he is presented, it is as a Balzacian or Dickensian semimonster, a miserly Grandet, or a preregeneration Scrooge. He is the antihero of Galsworthy's *Forsyte Saga*, Sinclair Lewis's *Babbitt*. Exceptional are the heroes of Horatio Alger, who wrote books for boys praising business and businessmen in a period in America when business was unusually lawless and businessmen unusually ruthless—the era of the silk-hatted "robber barons."

Subjective change is required by objective change; after the logic of industrialism must come the esthetics of the cultural revolution. For man, the social and the cultural are the same thing. Every profound cultural change is also a social change, and every social revolution is necessarily a cultural one. Societies are, of course, composed of men, and it is when men rather than things change that there is a true social revolution. In a time of change, men begin to differ in character from those who went before them because, as the makers of a revolution, they are reciprocally shaped by what they are shaping. They are a new kind of man because they are making something new. Yesterday's revolutions were the traders' objective, logical revolution and the technologists' objective, industrial revolution. These revolutions were embodied in the businessman and the engineer, who were unmistakably different in every respect from the characteristic figure of feudal medievalism, the monk. The revolution in the making today is the socially subjective cultural revolution. It must be ideological and esthetic and, of all social changes, it must be manifest first in a human change.

The affirmation of the coming esthetic revolution will be found in artistic commitment. Man will again believe in the arts. The ideological mass arts will be based on the arts of all the past except the individualistic, nonideological arts of capitalism. They will be polychromatic, audio-visual, multimedia, disposable, reproducible, and totally environing.

The ideology of the future must be the ideology of art itself. Ideology is the expression of consciousness. It is esthetics speaking through living man. It is art working through the subjective and emerging as action. In ideology, art becomes beliefs, religions, philosophies, organizational ties,

psychologies, notions of reality. The mind of every grown-up member of every human society is an ideological fabric. Ideology sometimes is a snarl of crossed thoughts and knotted loyalties. When this is true, the arts which spun the illusory threads of ideology, must be called to unravel and reorder them. Art, conscious of itself, must become responsible for everything socially subjective in man's environment, just as the sciences, technology, and industry are taking as their responsibility everything that is objective to the society, from microorganisms to the weather and space travel.

Ideologies are organization-wide esthetics. They are group beliefs generated by the arts. To speak of an ideology of capitalism would be to some extent a contradiction in terms since the purely pragmatic ideology of capitalism is the negation of ideology. The trader had to guard against the illusions and the ideologies of art, and he had to be ready to operate outside of any group, including those to which he apparently belonged. In the raid on the United States gold standard in 1967-68, some of those selling dollars for gold were American corporations trading in the exchanges of foreign countries. The numerous multinational corporations can have no national loyalties. Capitalist "ideology," contradicting traditional feudal beliefs, has not found a social faith of its own. It is the antithesis of belief and collectivism, expressed most clearly in agnostic, pragmatic individualism.

Ideology has been called a "false reality." While partially true, this comment does not recognize the art-basis of belief, including belief in any particular reality. Ideology is false to reality only to the extent to which art is thought of as a falsification of reality. This challenge to ideology derives from a view that recognizes reality only in its definable and static aspects. Such partiality can be corrected when existence in its totality is conceived of through the arts in conjunction with the sciences. Ideologies in such an art-science synthesis would not appear as false but would simply be seen as ways of dealing with the paradox of a formal, lawful, yet ever-changing world.

Art power to create and operate the new ideology is everywhere at hand. It is unemployed and ready to work at a synthesis of esthetics and logic, of humanism and industrialism, in which future man and his children will be able to live in dignity. As pre-Church cultures gave the bourgeoisie their anti-Church cultural base, so surviving precapitalist ideologies today show us alternate ways of life. The new ideologists can work with tribal and feudal allies and use their arts against capitalism, just as the bourgeoisie used classical art against feudalism.

The esthetic revolution will be a subjective revolution in direct contradiction to the objective technological revolution, which ended in industrialization. The arts will not be an esthetic means to a nones-

thetic end, as they were for the bourgeoisie. In creating and recreating arts to bring about a revolutionary subjective-social change, the art-means themselves become inseparable from the ends sought as they are absorbed in a changing audience. Such arts will constitute the revolutionized social environment in which revolutionary man, art-man, a consciously esthetic creature, will appear.

The ideology of the esthetic revolution will be belief in art. The nonideological, socially neuter arts of the bourgeois period will be replaced by ideological arts. Man will see himself as a being who requires conditioning by his own arts and will act accordingly. He will turn to the stores of his cultural heritage, some of which are hidden in the magical ritual of religions. Births, marriages, and deaths, when secularized under capitalism, were made feelingless to the extent that they were made artless. Seeing his subjective sociality and individuality as art-created, future man will adorn his days with desacralized ceremonies and rituals. He will, if he chooses, mark the winter solstice with symbolic charades of sacrifice and birth. And he will perhaps observe the equinoxes as passovers and resurrections, and feast in celebration of the harvest. Such observances would, at the least, affirm the ideological character of all past noncapitalist arts.

In the esthetic revolution, Everyman, the artist, will bring his cultural heritage forward, rejecting only the ideologically empty art of the latest past, that of the bourgeoisie. Unlimited productive power and material wealth are at hand, waiting only for anesthetic capitalism to be put aside. The new way of life cannot be brought about by cold reason. It is not a task for data processers, whether human or computerized. It is a task for the myth-makers.

What is expressed in mythology is not the detail of the petty fact but the nondefinitive realities of man's sufferings, his joys, and his hopes. Precapitalist arts and the arts and ideologies developed in the struggles of colonial peoples, nonwhites, labor, and the poor against the bourgeoisie have provided the beginnings of the anticapitalist world mythology. In capitalism itself, the mass arts are covertly or overtly anticapitalist. They have created universally accepted symbols with which ideological arts can make the esthetic revolution.

In the Middle Ages, everyone learned through the arts about the villainy that crucified a god and tortured the saints. Everyone knew what heaven and hell looked like, from fanciful descriptions and pictures. The arts had created an all-inclusive mythology and ideology and a belief in a "false reality."

Belief today, in the industrialized parts of the world, awaits its creation, its renaissance, in the arts. Everyone suspects that racial, sexual, and class injustices are constitutionally necessary to capitalism. Everyone

knows that dissidents are persecuted. From cartoonists, among other artists, everyone has learned who the villains are that stand between the people and the realization of the future. The boss, the dollar sign, the moneybags, the monopolist, and the imperialist are known and accepted as today's symbols of evil. In contradiction, the revolutionary artists will make themselves the symbols and the realities of the better future being born here on earth.

The artists as revolutionaries and the revolutionary artists will go to the people with the art works that will transform the people's minds. They will not try to beautify and so perpetuate the slums. They will not cool the ghettoes esthetically. They will not make misery tolerable in the tenements and so postpone the advent of the new society. At the same time, they will know that an affirmation of the value of life and the function of the arts is necessary to those who oppose capitalism, just as a nonesthetic stand was necessary to the traders when they overthrew feudalism. Belief in the arts as arts is the ideological key. What value-charged art says is so is experienced as so, and *is* so subjectively. When the arts no longer confuse or pacify and, instead, arouse the people, and there is no longer a passive consent of the governed, the die will be cast for the esthetic-cultural revolution.

BIBLIOGRAPHY

Barr, Stringfellow. *The Will of Zeus.* New York: Delta Books, 1961.

Beck, H., and H. E. Barnes. *Social Thought from Lore to Science.* New York: Dover Publications, Inc., 1961.

Benedict, Ruth. *Patterns of Culture.* Baltimore: Penguin Books, Inc., 1946.

Berelson, B., and G. A. Steiner. *Human Behavior, an Inventory of Scientific Findings.* New York: Harcourt, Brace & World, Inc., 1964.

Bernal, J. D. *Science in History.* London: C. A. Watts, 1957.

Berrill, N. J. *Sex and the Nature of Things.* New York: Pocket Books, 1955.

————. *Man's Emerging Mind.* New York: Premier Books, Fawcett World Library, 1957.

Bibby, Geoffrey. *The Testimony of the Spade.* New York: Alfred A. Knopf, Inc., 1956.

Bierstedt, Robert. *The Social Order, an Introduction to Sociology.* New York: McGraw-Hill Book Co., 1963.

Birket-Smith, Kaj. *Primitive Man and His Ways.* New York: Mentor, New American Library, 1963.

Boas, Franz. *Primitive Art.* Irvington-on-Hudson, N.Y.: Capitol, 1951.

Bourliere, Francois. *The Natural History of Mammals.* New York: Alfred A. Knopf, Inc., 1960.

Bourne, Geoffrey H. *The Ape People.* New York: Signet, New American Library, 1971.

Bowra, C. M. *Primitive Song.* New York: Mentor, New American Library, 1963.

————. *Classical Greece.* New York: Time, Inc., 1965.

Burtt, Edwin L., ed. *The English Philosophers from Bacon to Mill.* New York: Modern Library, Inc., 1939.

Calverton, V. F., ed. *The Making of Society.* New York: Modern Library, Inc., 1937.

Childe, V. Gordon. *Man Makes Himself.* New York: Mentor, New American Library, 1951.

————. *What Happened in History.* Harmondsworth, Middlesex: Penguin Books, Inc., 1950.

Chinoy, Ely. *Society, an Introduction to Sociology.* New York: Random House, Inc., 1963.

Clark, Grahame. *World Prehistory, an Outline.* Cambridge (Eng.): The University Press, 1961.

Collier, John. *Indians of America.* New York: Mentor, New American Library, 1951.

Coon, Carleton S., ed. *A Reader in General Anthropology.* New York: Holt, Rinehart & Winston, Inc., 1948.

Cornford, F. M. *From Religion to Philosophy.* New York: Torchbooks, Harper & Row, 1957.

Curtis, C. P., Jr., and F. Greenslet, ed. *The Practical Cogitator.* Boston: Houghton Mifflin Co., 1962.

Dampier, Sir William Cecil. *A History of Science and Its Relations with Philosophy and Religion.* Cambridge (Eng.): The University Press, 1942.

Darwin, Charles Robert. *The Descent of Man.* New York: Modern Library, Inc., 1936.

————. *The Expression of Emotions in Man and Animals.* Chicago: University of Chicago Press, 1965.

de Beer, Gavin. *Embryos and Ancestors.* New York: Oxford University Press, 1951.

de Coulanges, Fustel. *The Ancient City.* Garden City: Anchor, Doubleday & Co., Inc., 1955.

Drucker, Philip. *Indians of the Northwest Coast.* New York: McGraw-Hill Book Co., 1955.

Durkheim, Emile. *Montesquieu and Rousseau, Forerunners of Sociology.* Ann Arbor: University of Michigan Press, 1960.

Eiseley, Loren. *The Immense Journey.* New York: Vintage Books, 1957.

————. "Fossil Man and Human Evolution." Offprint from Thomas, ed., *Current Anthropology.* Chicago: University of Chicago Press, 1963.

Eliade, Mircea. *The Sacred and the Profane.* New York: Torchbooks, Harper & Row, 1957.

————. *Cosmos and History.* New York: Torchbooks, Harper & Row, 1954.

————. *Shamanism, Archaic Techniques of Ecstacy.* New York: Pantheon Books, Inc., 1964.

Ellis, Havelock. *The Dance of Life.* Boston: Houghton Mifflin Co., 1923.

Etkin, William, ed. *Social Behavior and Organization Among the Vertebrates.* Chicago: University of Chicago Press, 1964.

Fairservis, Walter. *The Origins of Oriental Civilization.* New York: Mentor, New American Library, 1959.

Farrington, Benjamin. *Greek Science*, Vol. I, *Thales to Aristotle*. Harmondsworth, Middlesex: Penguin Books, Inc., 1949.

Fischer, Ernst. *The Necessity of Art: The Marxist Approach*. Translated by Anna Bostock. London: Penguin Books, 1963.

Fletcher, Ronald. *Instinct in Man*. New York: Schocken Books, Inc., 1966.

Flornoy, B. *The World of the Inca*. Garden City: Anchor, Doubleday & Co., Inc., 1958.

Fox, H. Munro. *The Personality of Animals*. Baltimore: Penguin Books, Inc., 1947.

Frank, Lawrence K. "The World as a Communication Network," in *Sign, Image, Symbol*, edited by Gyorgy Kepes. New York: George Braziller, Inc., 1966.

Frankfort, H. et al. *Before Philosophy*. Harmondsworth, Middlesex: Penguin Books, Inc., 1951.

Fraser, Douglas. *Primitive Art*. Garden City: Doubleday & Co., Inc., 1962.

Frazer, Sir James George. *The New Golden Bough*, edited by T. H. Gaster. Garden City: Anchor, Doubleday & Co., Inc., 1961.

Gheerbrant, Alain. *The Impossible Adventure*. London: Readers Union, Gollancz, 1955.

Giedion, S. *The Beginnings of Art*. New York: Bollingen Series, Pantheon Books, Inc., 1962.

Gilbert, K. E., and H. Kuhn. *A History of Esthetics*. Bloomington, Ind.: Indiana University Press, 1953.

Gilliard, E. Thomas. *Living Birds of the World*. Garden City: Doubleday & Co., Inc., 1958.

Hauser, Arnold. *The Social History of Art*. New York: Vintage Books, 1957.

Hawkes, Jacquetta. *Prehistory*, History of Mankind, Cultural and Scientific Development, Vol. I, Part I. New York: UNESCO, Mentor, New American Library, 1965.

Hayes, Cathy. *The Ape in Our House*. New York: Harper & Bros., 1951.

Hegner, Robert. *College Zoology*. New York: The Macmillan Co., 1923.

————. *Parade of the Animal Kingdom*. New York: The Macmillan Co., 1942.

Henry, Jules. *Jungle People*. New York: Vintage Books, 1964.

Hibben, Frank C. *Digging Up America*. New York: Hill & Wang, Inc., 1960.

Howells, William Dean. *The Heathens*. Garden City: Anchor, Doubleday & Co., Inc., 1962.

————. *Back of History*. Garden City: Doubleday & Co., Inc., 1954.

Hoyle, Fred. *Frontiers of Astronomy*. New York: Harper & Bros., 1955.

Hughes, E. R., ed. *Chinese Philosophy of Classical Times*. New York: Everyman's Library, 1954.

Huxley, Julian. "The Courtship of Animals," in *A Treasury of Science*, Harlow, Shapley, ed., New York: Harper & Bros., 1958.

Jacobs, Jane. *The Death and Life of Great American Cities*. New York: Random House, Inc., 1961.

James, William. *The Varieties of Religious Experience*. New York: Mentor, New American Library, 1958.

Josephy, Alvin, ed. *Book of Indians*. New York: American Heritage Publishing Co., Inc., 1965.

Joyce, James. *Finnegans Wake*. New York: Viking Press, Inc., 1943.

Kasner, E., and J. R. Newman. *Mathematics and the Imagination*. New York: Simon & Schuster, Inc., 1940.

Klineberg, Otto. *Social Psychology*. New York: Henry Holt & Co., Inc., 1940.

Kohler, Wolfgang. *The Mentality of Apes*. New York: Vintage, Random House, Inc., 1959.

Lorenz, Konrad. *On Aggression*. London: Methuen & Co., 1968.

Lundberg, G. A., et al. *Sociology*. New York: Harper & Row, 1963.

Marcuse, Herbert. *One-Dimensional Man*. Boston: Beacon Press, 1963.

Marx, Karl. *The Economic and Philosophic Manuscripts of 1844*. Dirk J. Struik, ed. New York: International Publishers, Inc., 1964.

Maybury-Lewis, David. *The Savage and the Innocent*. Cleveland: World Publishing Co., 1965.

McLuhan, Marshall. *Understanding Media: the Extensions of Man*. New York: McGraw-Hill Book Co., 1964.

————. *The Gutenberg Galaxy*. Toronto: University of Toronto Press, 1962.

McNeill, William Hardy. *The Rise of the West*. Chicago: University of Chicago Press, 1963.

Milgram, Stanley. *Obedience to Authority, an Experimental View*. New York: Harper & Row, 1973.

Montagu, Ashley. "The Origins of Modern Man," in *Physical Anthropology and Archeology*, edited by Peter B. Hammond. New York: The Macmillan Co., 1964.

Montet, Pierre. *Everyday Life in Egypt in the Days of Rameses the Great*. London: Edward Arnold, 1958.

Morley, Sylvanis Griswold. *The Ancient Maya*. London: Oxford University Press, 1947.

Movius, Hallam, Jr., "The Old Stone Age," in *Anthropology Today*, edited by A. L. Kroeber. Chicago: University of Chicago Press, 1953.

Myrdal, J., and G. Kessle. *Angkor, an Essay on Art and Imperialism.* New York: Pantheon Books, 1970.

My Secret Life. New York: Grove Press, 1966.

Needham, Joseph. *Science and Civilization in China.* Cambridge (Eng.): The University Press, 1956.

————. *The Past in China's Present.* London: Far East Reporter.

Neuberger, Albert. "The Technical Skills of the Romans," in *A Reader in General Anthropology,* edited by Carleton S. Coon. New York: Holt, Rinehart & Winston, Inc., 1948.

Newman, James R., ed. *The World of Mathematics.* New York: Simon & Schuster, Inc., 1956.

Nietzsche, Friedrich. *The Birth of Tragedy* and *The Genealogy of Morals.* Garden City: Anchor, Doubleday & Co., Inc., 1956.

Pavlov, Ivan R. *Lectures on Conditioned Reflexes.* New York: Liverwright Publishing Corp., 1928.

————. *Conditioned Reflexes and Psychiatry,* Vol. II, introduction by W. H. Gantt. New York: International Publishers Co., Inc., 1941.

Piaget, Jean. *The Child's Conception of the World.* London: Humanities Press, 1951.

————. "Developmental Psychology," in *The International Encyclopedia of the Social Sciences,* edited by David L. Sills. New York: The Macmillan Co., 1968.

Piggott, Stuart. *The Prehistory of India.* Harmondsworth, Middlesex: Penguin Books, Inc., 1950.

————. *Ancient Europe.* Chicago: Aldine Publishing Co., 1965.

————. *The Dawn of Civilization.* New York: McGraw-Hill Book Co., 1961.

Reynolds, Vernon. *The Apes.* New York: E. P. Dutton, 1967.

Rokeach, Milton. *The Three Christs of Ypsilanti.* New York: Alfred A. Knopf, Inc., 1964.

Ruch, Floyd L. *Psychology and Life.* Chicago: Scott, Foreman & Co., 1941.

Schaller, George B. *The Year of the Gorilla.* Chicago: University of Chicago Press, 1964.

Schmitz, Carl A. *Art and Religion of the Northeast New Guinea Papuans.* The Hague: Mouton, 1963.

Selsam, Howard. *What Is Philosophy?* New York: International Publishers Co., Inc., 1939.

————. ed. *Handbook of Philosophy* (translated and adapted from M. Rosenthal and P. Yudin, *The Short Philosophical Dictionary*). New York: International Publishers Co., Inc., 1949.

————. and H. Martel, eds. *Reader in Marxist Philosophy.* New York: International Publishers Co., Inc., 1963.

Senet, Andre. *Man in Search of His Ancestors.* New York: McGraw-Hill Book Co., 1955.

Shapiro, Harvey, ed. *Man, Culture and Society.* New York: Oxford University Press, 1956.

Shapley, Harlow. *Of Stars and Men.* Boston: Beacon Press, 1958.

———. ed. *A Treasury of Science.* New York: Harper & Bros., 1958.

Sherif, Muzafer. *The Psychology of Social Norms.* New York: Harper & Bros., 1936.

Sills, David L., ed. *The International Encyclopedia of the Social Sciences.* New York: The Macmillan Co., 1968.

Skinner, B. F. *Beyond Freedom and Dignity.* New York: Alfred A. Knopf, Inc., 1971.

Smith, Homer W. *Man and His Gods.* New York: Grosset & Dunlap, Inc., 1956.

Smith, M. W., ed. *The Artist in Tribal Society: Proceedings.* Symposium on the Artist in Tribal Society, London, 1957. Glencoe, Ill.: The Free Press, 1961.

Stent, Gunther S. *The Coming of the Golden Age, A View to the End of Progress.* Garden City: Natural History Press, 1970.

Stoughton, Holborn J. B. *The Need for Art in Life.* Girard, Kans.: Pocket Series, Haldeman-Julius, 1915.

Swann, Peter C. *Chinese Monumental Art.* New York: Viking Press, Inc., 1963.

Szillard, Leo. *The Voice of the Dolphins.* New York: Simon & Schuster, Inc., 1961.

Thomson, George. *Studies in Ancient Greek Society.* London: Lawrence & Wishart, 1949.

———. *Aeschylus and Athens.* New York: International Publishers Co., Inc., 1950.

Tinbergen, Niko. *The Study of Instinct.* New York: Oxford University Press, 1951.

———. *Social Behavior in Animals.* London: Methuen & Co., 1953.

Turnbull, Colin. *The Forest People.* Garden City: Anchor, Doubleday & Co., Inc., 1962.

Vaillant, G. C. *The Aztecs of Mexico.* Harmondsworth, Middlesex: Penguin Books, Inc., 1950.

Vanishing Peoples of the Earth. Washington, D.C.: National Geographic Society, 1968.

Washburn, S. L. "Human Evolution," in *What Is Science?* edited by James R. Newman. New York: Simon & Schuster, Inc., 1955.

Weber, Max. *The Protestant Ethic and the Spirit of Capitalism.* New York: Charles Scribner's Sons, 1958.

Wells, H. G. *The Pocket History of the World.* New York: Pocket Books, 1941.

Weltfish, Gene. *The Origins of Art.* New York: Bobbs-Merrill Co., Inc., 1953.

Westheim, Paul. *The Art of Ancient Mexico.* Garden City: Anchor, Doubleday & Co., Inc., 1965.

Weyer, Edward, Jr. *Primitive Peoples Today.* Garden City: Dolphin, undated.

Whitehead, Alfred North. *Science and the Modern World.* New York: Mentor, New American Library, 1948.

Wilson, John Howard. *The Private Life of Mr. Pepys.* New York: Dell Publishing Co., Inc., 1959.

Winspear, Alban Dewes. *The Genesis of Plato's Thought.* New York: Russell & Russell, 1956.

Wissler, Clark. *Man and Culture.* New York: Thomas Y. Crowell Co., 1923.

Woodsworth, R. S., and M. R. Sheehan. *Contemporary Schools of Psychology.* New York: Ronald Press Co., revised 1964.

Woolley, Sir Leonard. *Ur of the Chaldees.* Harmondsworth, Middlesex: Penguin Books, Inc., 1950.

————. *The Beginnings of Civilization,* History of Mankind, Cultural and Scientific Development, Vol. I, Part II. New York: UNESCO, Mentor, New American Library, 1963.

Zuckerman, Sir Solly. *The Social Life of Monkeys and Apes.* London: Paul Keegan, Trench, Trubner, 1932.

INDEX

137